chibi!

THE OFFICIAL **Mark Crilley** HOW-TO-DRAW GUIDE

IMPACT

CINCINNATI, OHIO
IMPACTUniverse.com

CONTENTS

WHAT YOU NEED

Many aspiring artists worry too much about art supplies. There almost seems to be the belief that buying the right stuff is the single most important part of creating great art, but that's like thinking you'll be able to swim as fast as Olympic gold medalists do by wearing the right swimsuit. It doesn't work that way.

What really matters is not the pencil but the brain of the person holding it. Experiment to find the size, styles and brands you like best. If it feels right to you, that's all that matters.

PAPER

I almost want to cry when I see that someone has put hours and hours of work into a drawing on a piece of loose-leaf note-book paper. Do yourself a favor and get a pad of smooth bristol. It's thick and sturdy and can hold up to repeated erasing.

PENCILS

Pencils come down to personal preference. Perfect for me may be too hard or soft for you. I like a simple no. 2 pencil (the kind we all grew up with), but there are pencils of all kinds of hardness and quality. Try some out to see what kind of marks they make. The softer the lead, the more it may smear.

PENS

Get a good permanent ink pen at an art store, one that won't fade or bleed over time. Don't confine yourself to superfine tips. Have a variety of pens with different tip widths for the various lines you need.

RULERS

Get yourself a nice clear plastic ruler so that you can see the art as you make lines. A 15-inch (38cm) ruler is good for even some of the longest lines.

KNEADED ERASERS

These big soft erasers, available in art stores, are great for erasing huge areas without leaving tons of pink dust behind. However, they aren't always precise, so feel free to use them in combination with a regular pencil eraser.

PENCIL SHARPENERS

I've come to prefer a simple handheld disposable sharpener over an electric one. You'll get the best use out of it while the blade is perfectly sharp.

Drawing a Chibi Face

Let's begin with a little practice lesson. This will help you get used to the step-by-step teaching method I'll be using throughout this book. Your drawings don't need to be perfect. Just do your best and have fun with it!

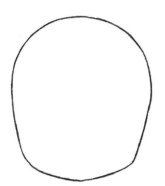

1 Draw the Head Shape

Using a pencil, draw the shape of a chibi head. The top of the head is very much like a circle. The sides are straight lines, tilted inward just a bit, and the bottom curves gently to form the chin.

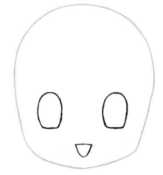

2 Add the Eyes and Mouth

Add the shapes of the eyes and mouth. Note that the eyes are very far from the top of the head. (This is true of almost all chibi drawings.) The eyes are oval-shaped but flattened a bit on the bottoms.

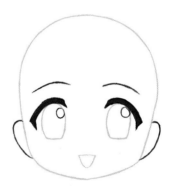

3 Draw the Eyebrows, Eyelashes and Ears

Draw eyebrows, upper eyelashes and ears. The eyelashes are quite thick. I've added a small circle in the top of each eye to make them appear shiny. Note how low the ears are on the head compared to the eyes.

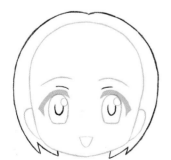

4 Draw the Hair Outline

Draw a basic outline of the hair that roughly follows the shape of the head. I've added details to the eyes: eyelid folds above each eyelash and a U-shaped line inside each iris to indicate the pupil.

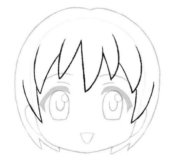

5 Add the Hair Details

Almost done! Just add a series of V-shaped lines to serve as her bangs. Note that they all point in slightly different directions, curving across the shape of the forehead.

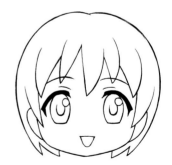

6 Ink All the Lines

Take your pen and ink all the lines. Allow plenty of time for the ink to dry, then erase all the penciled guidelines. Congratulations! You've drawn a chibi head, and you're ready to move on to the next lesson.

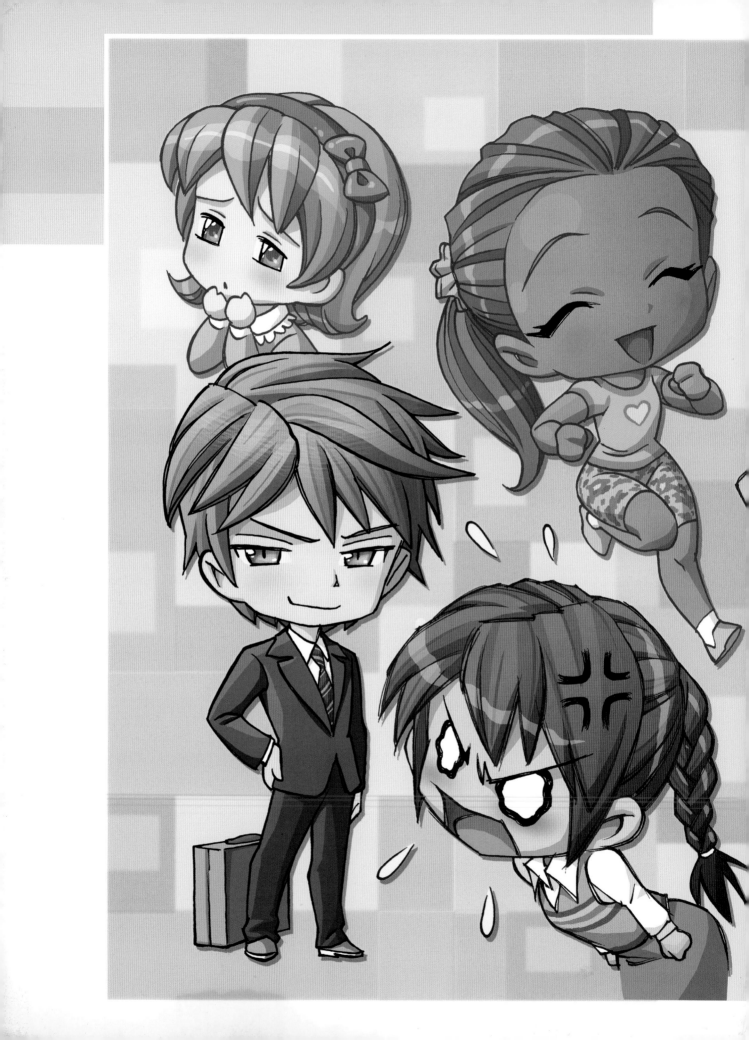

Chibi Basics

Chibis have a more lighthearted spirit to them than other manga characters, and I believe the process of learning how to draw them should be similarly lighthearted. Rather than sweating over lessons on anatomy and perspective, why not just hop straight into drawing chibis in all their hyper-cute glory? The ten lessons in this first chapter will allow you to do just that.

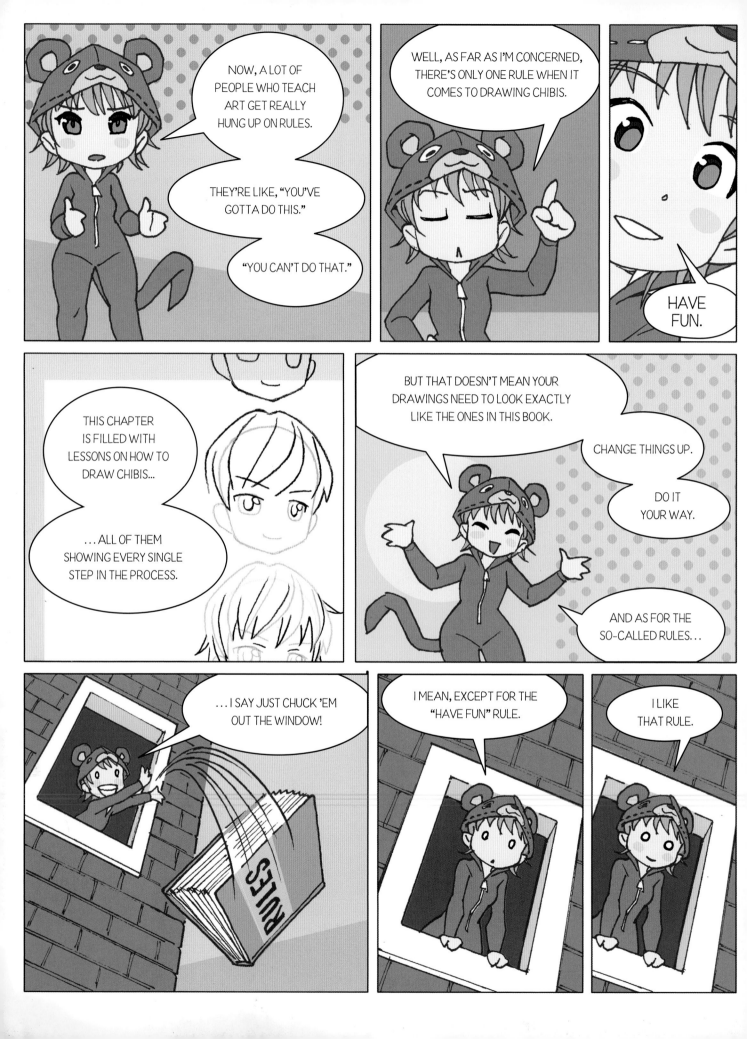

CHIBIS: AN INTRODUCTION

The Japanese word *chibi* is really just an all-purpose slang word meaning "short person," and in Japan its usage is by no means confined to cartooning. But outside of Japan, the word is mostly used to describe a particular Japanese cartooning style: one in which characters are drawn with large heads, tiny bodies and—very often—greatly exaggerated facial expressions.

Within the world of manga storytelling, characters are often drawn in two different ways within the same story. Most of the time they are seen in their standard form with fairly believable body proportions. But at key moments, for a comical effect, they may briefly morph into their giant-headed chibi form. These sudden transformations allow manga artists to make a moment of anger, for example, much cuter and more lighthearted than it would be if standard body proportions were maintained.

That said, many chibis you see these days aren't part of any story. They are stand-alone illustrations of chibi characters, often doing nothing more than striking a pose against a white background. So, if you're not working on an epic manga story at the moment, not to worry. This book is for people who simply want to draw chibis for the sheer pleasure of it.

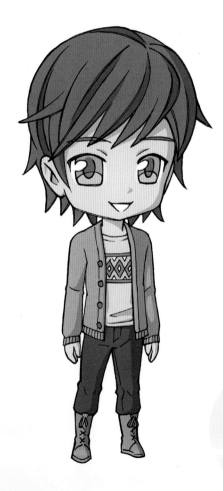

CHIBI PROPORTIONS...

Compare these two illustrations to gain a sense of how standard manga proportions differ from chibi proportions. This will help you get the basic idea before we jump into our first big drawing lesson.

Curious about how to draw a real person as a chibi? Sit tight. There's a lesson about that coming up in Part 3.

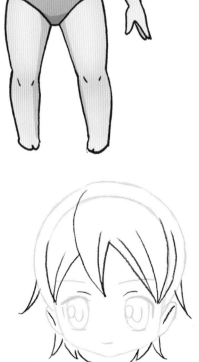

Basic Chibi Girl

Every artist should find his own method of drawing chibi proportions. For some, an exaggerated cartoony approach is ideal: gigantic heads with tiny little bodies. Others prefer chibis that appear quite tall and elegant. For our first full step-by-step lesson, I thought it would be best to go for something between the two extremes.

Let's begin with a female character that is a little more than two heads tall. In later lessons we'll learn interesting poses, but for now let's stick with a chibi who's just standing there. This will help us focus on the length of the arms and legs compared to the rest of the body.

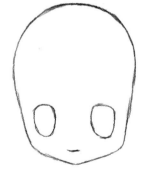

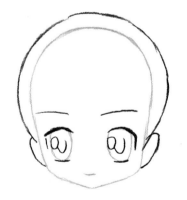

1 Draw the Head Shape and Eyes

Draw a head shape that is considerably taller than it is wide. Make the top of the head round with contour lines that straighten out as they descend to the cheeks. The large oval eye shapes are widely spaced and low on the face. The upper two-thirds of the head is almost all blank space. Add a short line for the mouth.

2 Add the Hair Contour and Eye Details

Place a curving line just above the circle of the scalp to serve as the contour line of the hair. Down near the cheeks add simple C-shaped lines for the ears. Draw eyebrows and then eyelash lines above and below the irises. Add ovals on one side of each iris for highlights and U-shaped lines for the pupils.

3 Draw the Hair and Facial Details

For the hairstyle, place a curving vertical line across the left side of the forehead, dividing the hair into two large sections. The strands of hair are curving V shapes, drawn with lines that follow the surface of the scalp. Add short diagonal lines to convey the structure of each ear, and little horizontal lines above each eyelash for the eyelid folds.

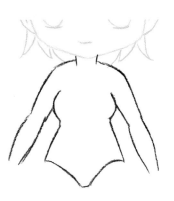

4 Draw the Torso

Draw two short lines for the neck, then draw the contours of the arms, taking care to focus on both the width and the length. They are roughly as long from shoulder to wrist as the head is from side to side. When drawing the waist area, take care to make the distance of its widest point (the area of the upper thighs) about the same as the width of the shoulders.

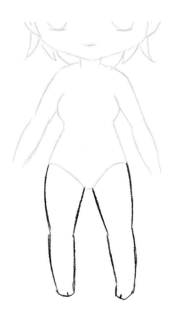

5 Draw the Legs

Now draw lines for the contours of the legs. The length of each leg from the top of the thigh to the tip of the toe is similar in length to the arms from shoulder to wrist. Chibi feet often have very little detail. In this case, I drew a small notch to suggest the big toe and left it at that.

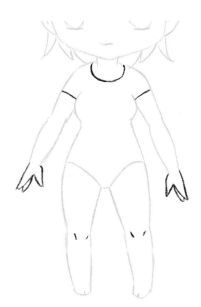

6 Add Clothing Details, Hands and Kneecaps

This lesson is all about body proportions, not clothing, so there's no need to replicate the garment choice I've made. Indeed, why not have fun and come up with clothing all your own? When drawing the hands, pay attention to their small size relative to the arm. I've added little vertical dashes on each leg to convey the kneecaps.

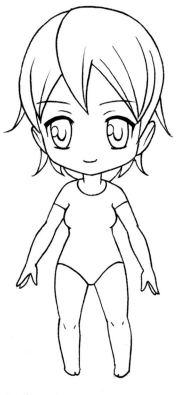

7 Ink the Drawing

Grab your favorite pen and ink all the lines. Leave time for the ink to dry, then erase all the pencil work. Congratulations! You've drawn a cute little chibi character of average proportions, head to toe.

Basic Chibi Boy

The approach to drawing body proportions doesn't really change when you go from drawing a female chibi to drawing a male. If you've made your female character two and one half heads tall, you can make your male character exactly the same height.

But you may use quite a different approach to drawing the body shape. In this lesson, you'll learn how to draw a basic chibi boy with a body shape that reads as male rather than female, even at a quick glance.

1 Draw the Head Shape and Eyes

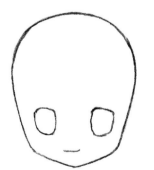

Just as with the female character, the head shape is taller than wide, rounded at the top, and has contour lines that straighten out as they descend to the cheeks. I made the eyes a little smaller than I did for the female version—a common method of conveying masculinity. Add a short line for the mouth.

2 Add the Hair Contour and Eye Details

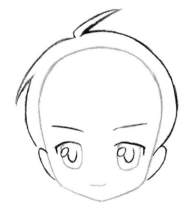

Place the hair contour just above the line of the scalp, adding a loose strand or two. The ears are simple C-shaped lines, down near the cheeks. Give a mischievous tilt to the eyebrows, then add eyelash lines that are much less bold than in the female version. Draw ovals on one side of each iris for highlights, and U-shaped lines for the pupils.

3 Add Hair and Facial Details

For the hairstyle, part the hair on the left side of the head, dividing the hair into two large sections. The strands of hair are curving V shapes, and many of them sweep diagonally across the forehead. Add short diagonal lines to convey the structure of each ear, and little horizontal lines above each eyelash for the folds of the eyelids.

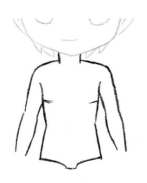

4 Draw the Torso

Draw two short lines for the neck, then draw the shoulders. Note that the shoulders are much wider than in the female version, and they angle more sharply at the edges. When drawing the waist, pay attention to the subtle angle of the contour lines in that area. As in the female version, the arms are roughly as long shoulder to wrist as the head is from side to side.

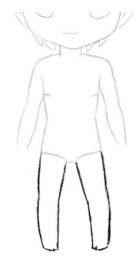

5 Draw the Legs

Now draw lines for the contours of the legs. Compared to the female version, the contours of the thighs are straighter with considerably less width between the lines. Draw the feet the same as in the female version with just a small notch to delineate the big toe.

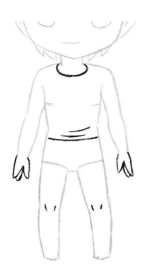

6 Add Clothing Details, Hands and Kneecaps

Have fun designing your own clothing choices. Horizontal lines at the waist can help to convey wrinkles in that area. When drawing the hands, feel free to simplify things. Many artists drawing chibis make no effort to separate the fingers. As in the female version, I've added little vertical dashes on each leg to convey the kneecaps.

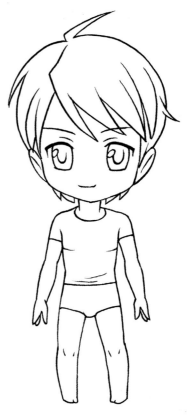

7 Ink the Drawing

Get your pen and ink all the lines. Allow time for the ink to dry, then erase all the pencil work. Nicely done! You've learned the key differences between drawing standard chibi male and female body shapes.

Super Short Chibi Girl

Now that we've looked at the proportions for an average chibi character, let's try drawing in a style that's more extreme. In the previous lessons the characters were a little more than two heads tall. But sometimes artists make the head so big that it's larger than the rest of the entire body. The result is a highly stylized super short chibi—an approach that goes all in and pushes the chibi look to its limits.

As before, let's stick with a "just standing there" pose so as to focus on the proportions. And fair warning: You just might get hooked on this drawing method. For some artists, it becomes the only way to chibi!

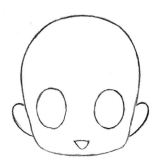

1 Draw the Head Shape and Eyes

Begin by drawing the basic shape of the head. It is taller than it is wide but only by a small margin. Unlike in the previous lessons, the bottom is quite flat, with no point at the chin. The oval eyes are large with about one eye's width of space between them. They are low on the head but not as low as in earlier lessons.

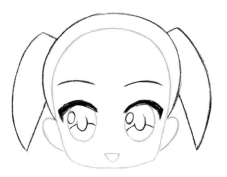

2 Add the Hair Contour and Eye Details

Place a curving line just above the line of the scalp to serve as the contour of the hair. Add a thick line above each iris to indicate the eyelashes. You can add a lower eyelash line if you like, or skip it, as I have done. I gave this character pigtails, but feel free to draw any hairstyle you like.

3 Draw the Bangs

Elsewhere in this book you will find me giving characters complex hairstyles, but here the look is deliberately flat. It's kind of a "symbol" of hair rather than the real thing. Nevertheless, I have tried to make the lines follow the curving surface of the scalp in a way that looks natural.

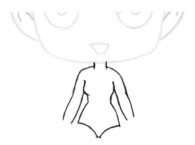

4 Draw the Pigtails and Add Facial Details

Divide the pigtails into a few simple V-shaped strands to make them look more like hair. Draw a hooked line on each ear to add structure, and add a short line above each eye to indicate the folds of the eyelids.

5 Draw the Torso

When drawing the upper body, pay attention to its small size in comparison to the head. The shape you're adding in this step is only just a little larger, top to bottom, than one of the eyes. The arms and the neck are of roughly equal width.

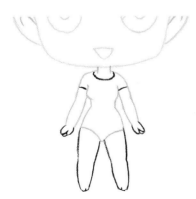

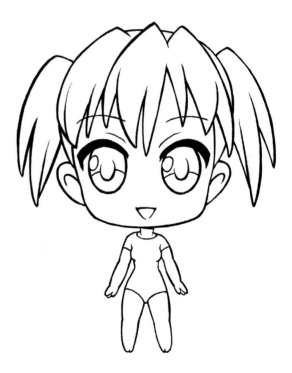

6 Add Legs, Hands and Clothing Details

Now draw the legs, making them around the same length as the arms, but considerably wider, especially at the thighs. Feel free to simplify the hands if you're having trouble with them. No need to make the clothes exactly as I have. Go ahead and make your own.

7 Ink the Drawing

Get your pen and ink all the lines. Then allow time for the ink to dry before erasing all the pencil work. Well done! You've learned how to draw a super short female chibi. In the next lesson, you'll learn the male version.

Super Short Chibi Boy

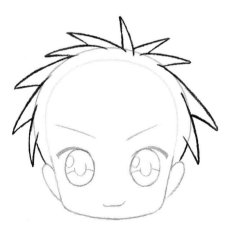

For the male version of the super short chibi, the basic structure remains largely the same. For many artists the difference between male and female characters is signaled mainly by the clothing and hair.

Let's make this the last of the "just standing there" lessons. It's great for learning basic proportions, but in the pages ahead we'll gradually move toward more interesting poses.

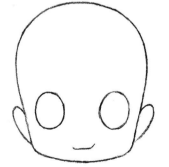

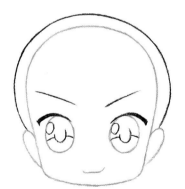

1 Draw the Head Shape and Eyes

Begin by drawing the basic shape of the head: taller than it is wide, but just barely. The bottom is quite flat, with no point at the chin. You may choose to make the oval eyes a bit smaller than those of the female character. Note that the ears are lower on the head than the eyes, leaving plenty of space for the hair.

2 Add the Hair Contour and Eye Details

Place a curving line just above the line of the scalp to serve as a guideline for the hair. Give a mischievous tilt to the eyebrows, a common chibi facial expression. As usual, the male eyelash lines are much less bold than the female's.

3 Begin Drawing the Hair

Add at least a half dozen V-shaped strands of hair across the top of the head. Each is pointing in a slightly different direction from the center of the head like the hands of a clock. No need to copy exactly what I've done. Have fun and make it your own!

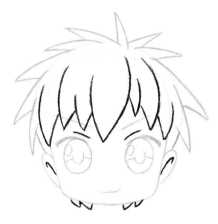

4 Finish the Hair and Facial Details

To complete the hairstyle, add more V-shaped lines vertically across the forehead. Note that they curve a bit to follow the surface of the head. Place a few small strands back behind the ears. A structural line in each ear and a line above each eye, for the eyelid fold, is all you need to finish things off.

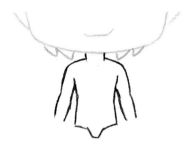

5 Draw the Torso

When drawing the upper body, notice its small size in comparison to the head. You can use the height of each eye to help get the right proportions for the upper body. The shoulders are much broader than in the female version: a go-to method for emphasizing a character's masculinity.

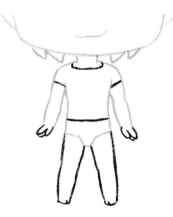

6 Add Legs, Hands and Clothing Details

Now draw the legs, making them roughly match the arms in terms of length. The legs are narrower than in the female version, especially in the thigh area. The hands can be identical to those of the female character. As always, design the clothing as you wish.

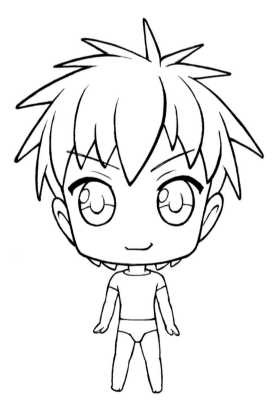

7 Ink the Drawing

Take your pen and ink all the lines. Allow the ink to dry, then erase all the pencil work. That's it! You've learned how to draw a super short male chibi. In the next lesson, we'll find out what a tall chibi design looks like.

Tall Chibi Girl

A tall chibi character may at first seem like a contradiction in terms. Aren't chibi characters supposed to be short? Well, yes, but that doesn't mean every one you draw has to be only two heads tall. Some artists like their chibis to be a little less babylike in appearance.

In this lesson, we'll learn how to draw a female chibi that is well over three heads tall. She will still be recognizable as a chibi-style character, but her height and body shape will not be such a wild departure from actual human anatomy.

1 Draw the Head Shape and Facial Features

As always, begin by drawing the basic shape of the head. As an added challenge, we'll be drawing the face slightly turned to our right. This means all the facial features are shifted slightly to the right. Some artists will even make one eye a little smaller than the other to show that it's farther away.

2 Add the Hair and Eye Details

To make the eyes seem shinier, I've given each of them two highlights: a large one in the upper right of the iris and a smaller one in the lower left. I've chosen a pigtailed hairstyle that suits a woman with longer hair. But remember: You should feel free to change the hairstyle as you please.

3 Add the Hair Details

Since this chibi has proportions that are a little more true to life, I've decided to make the hair more realistic as well. This means more lines throughout, running vertically down from the crown of the head. Now is also a good time to add eyelid folds above the eyes and a line or two to the ears.

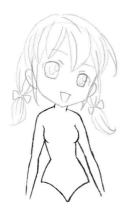

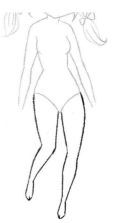

4 Draw the Upper Body

This is by far the most realistic-looking body we've drawn so far, so you'll want to take your time. Carefully study the length and angle of each line before you draw it. Note that the height of this part of her body is a little greater than the height of her head. The widest point of her hips should match that of her shoulders.

5 Draw the Legs

Now add the legs. Rather than a "just standing there" pose, let's liven things up by bending the legs at the knees. The length of the legs is greater than that of the torso, top to bottom. The thighs are at least twice the width of the calves. I've made the feet extra small to give them a delicate appearance.

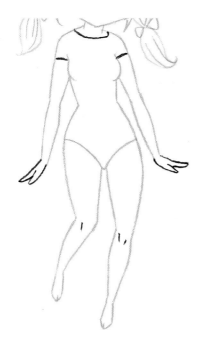

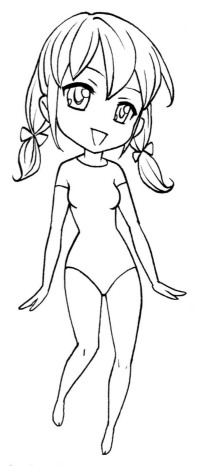

6 Add Hands, Kneecaps and Clothing Details

Hands are notoriously difficult to draw, so take your time here. At this angle, only the thumbs and pointer fingers of each hand are visible, simplifying things considerably. Draw the kneecaps by adding one or two short vertical lines. As always, feel free to alter the clothing according to your own tastes.

7 Ink the Drawing

Take your pen and ink the lines. Leave plenty of time for the ink to dry, then erase the pencil work. It may have been challenging, but you did it! You drew a tall female chibi with fairly realistic anatomy.

Tall Chibi Boy

That last lesson was probably the trickiest of the book so far. The curved lines of the body require subtlety, and you might not always get them right the first time. The male chibi's body is composed mostly of straight lines and should prove a bit easier to draw than its female counterpart.

Continuing our move toward more interesting poses, let's have him resting one hand on his hip. Even a small choice like this can go a long way toward breathing life into a pose.

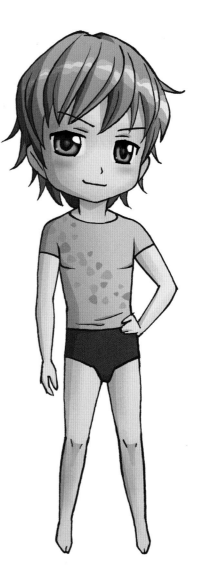

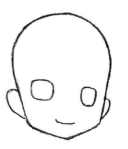

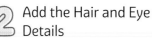

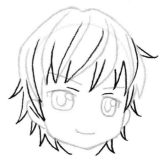

1 Draw the Head Shape and Facial Features

Begin by drawing the basic shape of the head. As in the Tall Chibi Girl lesson, he'll have his face slightly turned to the right. Remember to pay attention to the blank spaces between the eyes, the mouth and the chin. Replicating these areas is an essential part of getting the proportions right.

2 Add the Hair and Eye Details

Many hairstyles include a parting of hair near the crown of the head. Here, you can see an indentation in the contour of the boy's hair at the point where the part occurs. Most of the strands of hair then emanate from that point, the lines curving as they flow across the forehead. Note that the boy's eyelash lines are much thinner than the girl's.

3 Add the Hair Details

Now that you've got the basic structure of the hair in place, add details. To give the boy's hair a slightly disheveled look, add a lot of small V-shaped lines along the sides and bottom of the hair that curve away from the head. Structural lines in the ears and eyelid folds above each eye give the face an extra touch of detail.

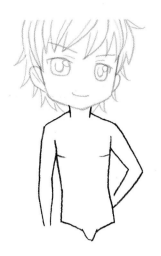

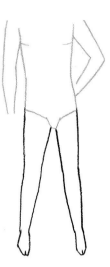

4 Draw the Upper Body

When drawing the shape of the torso pay attention to its height. It's a little more than the height of his head. The width of the shoulders is roughly equal to that of the head. There is a small indentation of the torso contour at the waist, but it is very slight compared to that of the tall female chibi.

5 Draw the Legs

For both the male and female character, I've drawn the legs in a "floating" pose, where the feet don't seem firmly planted on the ground. It's a common choice for artists drawing chibis to give the character a lighter-than-air quality. The thighs are wider than the upper arms, but only just a little.

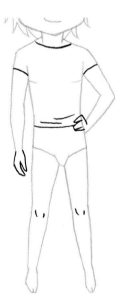

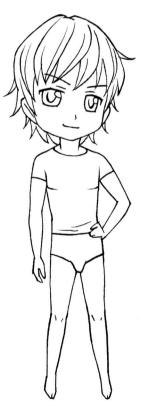

6 Add Hands, Kneecaps and Clothing Details

When drawing the hands, pay careful attention to the one that's resting on the hip since it's different from the hands we've drawn so far. The fingers aren't drawn in line with the wrist, but are instead shifted upward a bit. This helps the hand appear more three dimensional. A couple of horizontal lines at the waist can help convey wrinkles in the clothing.

7 Ink the Drawing

Ink all the lines. Allow time for the ink to dry, then erase all the pencil work.

Now that you've studied three different proportion systems for chibis—tall, average and super short—you're ready to find the style you like best. It could be one of the three, a blend of two or an entirely new style of your own creation.

CHIBI HAIRSTYLES

Almost all the lessons in this book involve drawing a hairstyle of some kind, so completing them will give you lots of experience drawing chibi hair. But you can never have too much practice, so here are some extra reference images you can turn to for ideas about different chibi hairstyles.

When trying to draw any hairstyle, pay attention to the basic structure. Often the majority of lines flow from a point near the crown of the head. Also focus on the length and the shape of the individual lines you're drawing. Some hairstyles are composed mainly of long, straight lines. In others, the lines are shorter or more curved.

CHIBI HAIR PROPORTIONS

When drawing chibi hair, an artist is forced to make an interesting choice. Should the hair's proportions be based on the size of the head? Or should they be drawn to match the body? Both methods are valid. Here you can compare the two approaches.

PROPORTIONAL TO THE HEAD..
In this version, the hair appears shockingly large in comparison to the body. That's only because the body is so small. If the body were enlarged to its proper size in relation to the head, the hair would reach to around the area of the lower back. This approach can be a fun way of calling extra attention to the hairstyle, adding visual interest to the entire drawing.

PROPORTIONAL TO THE BODY...
This version of the hair, though long, seems quite sensible in terms of its relationship with the body. It reaches the area of her lower back and comes to a stop. If you don't wish to call special attention to the hair, this method is the way to go.

Surprised Chibi

I've always felt one of the chibi style's most important superpowers is the ability to express emotions. A chibi-style facial expression can convey a character's emotional state in a way that is easily understood, adorable and hilarious, all at once. So there's no way this book could be complete if I didn't devote at least a few lessons to drawing chibi emotions.

Let's start with a look of surprise. And rather than focus exclusively on the character's body proportions, let's begin learning more about poses and distinctive clothing choices.

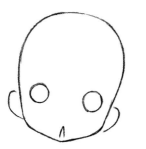

1 Draw the Head Shape and Facial Features

Begin by drawing the head shape. The top of the head is quite round, and the chin comes to a bit of a point. Now, the good news about chibi emotions is that the facial features are generally quite simplistic and cartoony. These eyes, for example, are nothing more than small circles. The mouth looks like a tiny, upside-down letter V.

2 Draw the Hair and Eyebrows

Enough with the tame hairstyles, let's have some fun! To replicate the style you see here, draw a bun-shaped ball of hair on each side of her head. Include a part in the hair at the crown of the head, then add big spiky bangs curving across her forehead. Finally add raised eyebrows and "blushies"—a few short vertical lines on her cheeks. (More about blushies at the end of this chapter.)

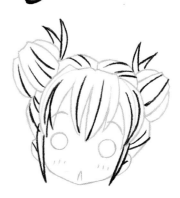

3 Add the Hair Details

This may look like a lot of detail, but most of it is just extra lines that follow along in the same direction as the lines you've already drawn. To liven things up a bit, add a couple stray hairs near the top of the buns. Add a pair of thin vertical strands in front of each ear, and you're done with her 'do.

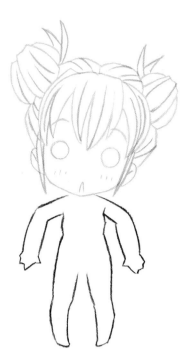

4 Draw the Body

This time try drawing the entire body all at once. Pay attention to the proportions. The height of the body, shoulder to toe, is just a little more than the height of the head. Try to reproduce the angle of her elbows and the slightly pigeon-toed pose of her feet. Both of these add to the look of surprise.

5 Draw the Clothing Basics

There is perhaps no clothing more typical of manga illustrations than the classic sailor suit school uniform. Draw the collar by adding two triangle shapes across her shoulders. By varying the bottom contour line of the skirt, you can make it appear pleated. Puff out the sleeves above the cuffs and add a simple shoe on each foot.

6 Draw the Clothing Details

Draw a necktie to complete the schoolgirl uniform. I decided to add a plaid pattern to the collar and the skirt, but you may want to make a different choice. Socks that reach to midcalf is what you'd probably see in Japan, but I thought having them go above the knee would be cute.

7 Ink the Drawing

Get your pen and ink all the lines. Leave some time for the ink to dry, then erase all the pencil lines. Congrats! You've drawn a seriously shocked chibi. You're ready to move on to another classic chibi emotion: joy.

Joyful Chibi

You could say that a smile is my default facial expression for a chibi character. If I'm drawing characters just for fun, most of the time I'll make them look happy rather than angry or devoid of emotion. But there's a difference between a friendly smile and a look of ecstatic joy. In this lesson we'll learn to draw the latter.

In all these lessons that focus on emotions, body language plays an important role. When drawing the pose shown in this tutorial, pay attention to how its carefree and energetic look adds to the sense of unbridled joy seen in the final image.

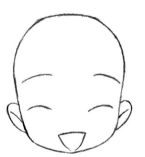

1 Draw the Head Shape and Facial Features

Begin by drawing the head shape. This time, I've gone for a more rounded style in which the chin doesn't come to a point. Draw the eyes as nothing more than little curved lines, but be careful about their placement. They are about one third of the way from the bottom of the head to the top. Putting the eyebrows high above the eyes adds to the elated look on this face.

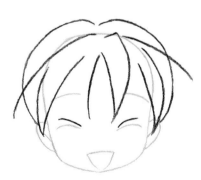

2 Draw the Hair and Eyelid Folds

Draw her bangs shooting off in all directions as a way of adding to the feeling of exuberance. Once again, there's an indentation in the contour line at the crown of the head, showing us the part in her hair. I've made the eyelid folds tilt inward to suggest eyes squinted shut.

3 Add the Hair Details

Now that you've got the structure of the hair in place, you can add extra lines to finish things off. A few short vertical lines just above the center of her forehead can help convey the structure of the bangs. I've put a single stray strand of hair at the top of her head to add a touch of liveliness.

4 Draw the Body

Take your time here, as this step requires extra attention to the angles of the lines and the blank spaces between them. Note that, even at its widest point, her body isn't as wide as her head, and, though her body is more than one head tall, it is taller only by a small amount. Drawing her left foot directly behind her left knee foreshortens the lower leg in that area.

5 Draw the Clothing Basics and the Hands

I thought a cheerleader outfit would be the perfect accompaniment for this super-peppy character. When drawing the hands, note that they are quite small, around the same size as the ears. Chibi hands hardly ever have long, fully defined fingers. I've made the fingers here super short, almost like the paws of an animal.

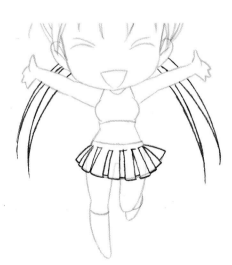

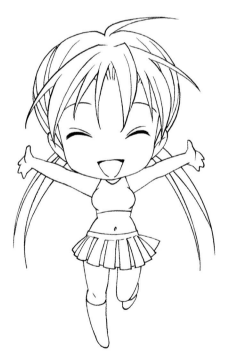

6 Draw the Clothing Details

Compared to the skirt in the previous lesson, this skirt has many more pleats, tightly packed together. Note again how varying the contour along the bottom edge of the skirt helps us see the skirt as pleated. For one last energetic touch, I've added long, curving pigtails behind her arms.

7 Ink the Drawing

Nearly done. All you have to do now is take your pen and ink all the lines. After the ink has dried, you can erase all the penciled lines.

Drawing happy chibis is certainly a lot of fun, but there are times when you need to illustrate a chibi character that is seriously bummed out. Our lesson on how to draw a sad chibi awaits us.

Sad Chibi

In the land of chibi drawings, pretty much anything can be made to look cute, even stuff that is normally serious or a little frightening. A skull and crossbones? Draw it chibi-style, and it's adorable. Punk rock anarchists? Draw them chibi-style, and suddenly they look like all they really want is a great big hug.

So it's no big surprise that even an unpleasant emotion like sadness can have the edge taken off when given the chibi treatment. In this lesson, we'll be learning how to draw a broken-hearted chibi, and, just as in our last lesson, the body language will be crucial.

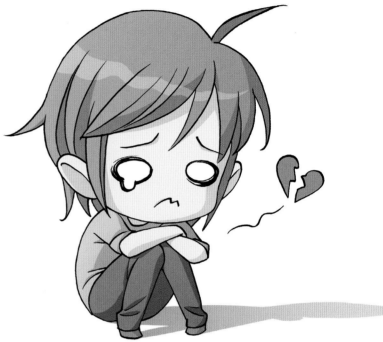

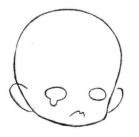

1 Draw the Head Shape and Facial Features

This time the head is turned pretty decisively into a three-quarter point of view. This means that when you draw the basic head shape, you need to put in an angle at the base of the cheek on the right side. Note also that the horizontal ovals of the eyes are shifted quite a bit over to the right. For extra sadness, add a little teardrop to one of the eyes.

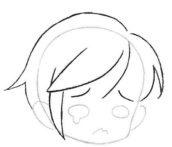

2 Draw the Hair and Eyebrows

As always, feel free to change the hairstyle. In my version, the parting of the hair is over on the right side of the head, and most of the strands of hair flow from that point. The MVPs in this step are the eyebrows. Curving them upward toward the middle of the forehead is an essential part of the dejection we see on this face.

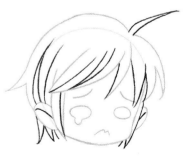

3 Add the Hair Details

Depending on your artistic preferences, you could decide to leave the hair unchanged from Step 2. If you do choose to add more lines as I have here, note how I've drawn a few extra short strands behind the ears. Speaking of ears, now's a good time to add a line or two in that area to define the structure.

4 Draw the Upper Body

Just as body language is important for expressing joy, it can also greatly accentuate the perceived sadness of a character. By having this boy curling in upon himself, we feel that he's shielding himself from further pain. Pay attention to the angle of the elbows and the way the arms cross each other near the wrists.

5 Draw the Legs

When drawing the legs in this pose, it's best to draw the lower legs (knees to feet) first. Note that the feet are a little pigeon-toed. This adds to the sense of the character turning inward.

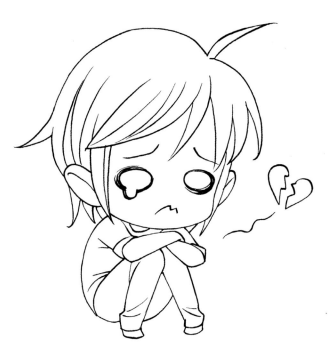

6 Draw the Clothing Details

Of all the lessons so far, this one offers the best opportunity to practice drawing clothing folds and wrinkles. Begin by adding lines at the waist and at the area behind the knee. Then add crescent shapes above each elbow to signify rolled-up sleeves. Finish by altering the contour of the pants near the feet and adding one or two wrinkle lines in that area.

7 Ink the Drawing

Get your pen and ink all the lines. When inking the eyes, you may choose to build up the thickness of the lines as I have. Once you've let the ink dry, erase the pencil lines.

Before we turn our attention away from chibi emotions, let's devote one more lesson to this topic: a step-by-step tutorial on drawing chibi anger.

Angry Chibi

When it comes to drawing chibi facial expressions, different emotions call for different levels of exaggeration. If I had to say which feeling tends to be depicted in the most exaggerated way, I'd probably choose anger. Something about this most heated of emotions makes artists really stretch those little chibi faces to their limits.

In this lesson we'll learn how to draw a truly furious chibi, and this time the body language will be more important than ever.

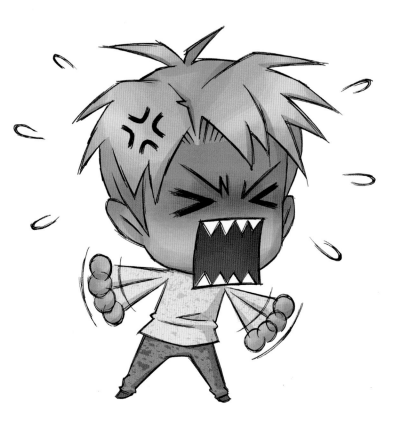

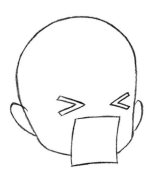

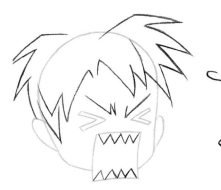

1 Draw the Head Shape and Facial Features

The first thing you'll notice is that the mouth—more or less a perfect square—extends all the way past the contour line of the head. This is, of course, a physical impossibility, but that's why I love it so much! The eyes are little V shapes, pointing toward each other.

2 Add the Hair, Eyebrows and Teeth

Sometimes the hairstyle can play a role in expressing emotion. To me, nothing says "anger" quite like an unruly spiky hairdo. See the zigzag shape connected to one of the eyebrows? It adds to the intense facial expression, indicating a furrowed brow. And, speaking of spiky, giving his teeth the crocodile treatment pushes this facial expression entirely over the top, which is right where we want it to be.

3 Add Hair Details and the "Vein of Anger"

Some of you may already be familiar with the arrangement of thick curved lines on the upper left side of his head. It is the all-purpose chibi anger symbol (more about emotional imagery at the end of this chapter). Want to show that he's really blown a gasket? Draw sweat drops flying off in all directions. Then add more detail to the hair and ears.

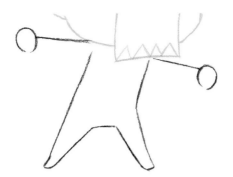

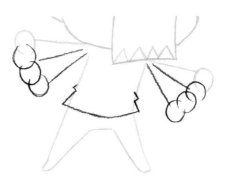

4 Draw the Basic Structure of the Body
This lesson is unique in that it features a type of motion blur effect on the chibi's arms, helping the viewer to understand that he's comically flapping his clenched fists up and down. Begin with just two "lollipop" style arms. When drawing the body, make sure to shift it over to the right, to show that this chibi is leaning forward, giving full vent to his rage.

5 Draw the "Motion Blur" Effect
Add several more balled-up fists below each of the fists from the previous step, taking care to make them overlap, like the rings of the Olympic flag. Then add a couple extra arm lines on each side, fanning out from the shoulders. For clothing, let's keep things simple—jagged line across his waist to create the effect of an untucked shirt.

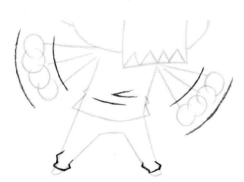

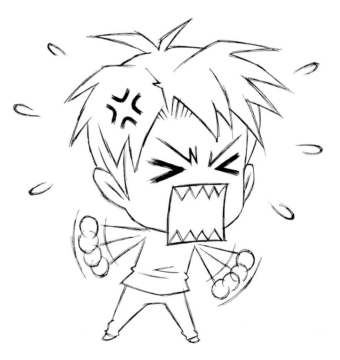

6 Add the Final Details
By adding a few curving lines on either side of the fists, we can complete the motion blur effect. It's a useful tool to have in your chibi toolbox: not just for raging characters like this one, but for any chibi who is frustrated in a comical way. Add a few more wrinkles in the areas of the waist and pant cuffs, and the pencil linework is done.

7 Ink the Drawing
Take your pen and ink all the lines. Allow plenty of time for the ink to dry, then erase the pencil lines.
Drawing chibi characters is always fun, but drawing angry chibis is downright therapeutic. Next time something's getting on your nerves, draw an angry little chibi and see if it doesn't help get all that rage out of your system!

EMOTION SYMBOLS IN MANGA

As we saw in the Angry Chibi lesson, manga artists have developed special symbols that serve as a sort of visual shorthand for conveying emotions. These are useful throughout a great many types of manga and anime, but they are especially prevalent when it comes to drawing chibis. On these pages you can familiarize yourself with all the most important emotion symbols and see how they are used.

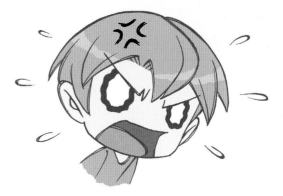

THE VEIN OF ANGER......................................

In both this drawing and the one in the Angry Chibi lesson, you can see the same arrangement of curved black lines that compose the anger symbol. Originally, these lines were meant to illustrate a bulging vein on the forehead: classic evidence of someone getting hot under the collar. Pay attention to the eyes and mouths when comparing these two faces of chibi anger. They convey two very different levels of rage.

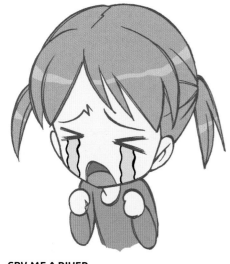

CRY ME A RIVER...

In the Sad Chibi lesson we learned how to draw a chibi on the verge of tears. Here we see what a chibi looks like when the waterworks really get flowing. Note how the little rivers work in coordination with both the eyes and the eyebrows. You need all three to get the final effect.

SWEAT DROP...

This is certainly among the most common chibi emotion symbols. Of course, for decades cartoonists have drawn characters sweating as a way of showing nervousness. But Japanese artists took the idea and pushed it so far that it became a single gigantic icon, seemingly on its own plane of reality.

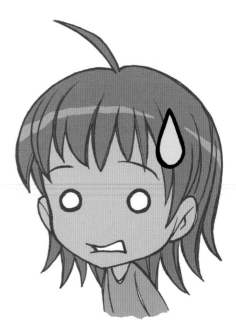

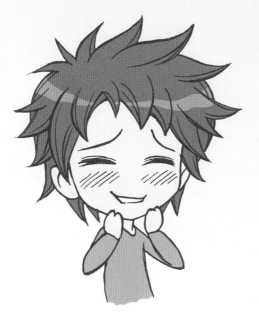

THE BLUSHIES...
A few diagonal lines across the cheeks is all it takes to convey shyness or embarrassment. Some artists become so hooked on the idea of adding blushies, they put them on almost every chibi they draw. (I may or may not be talking about myself!)

HEART EYES...
Nothing says love at first sight quite like eyes that have morphed into hearts. Indeed, this visual has made its way into the world of emojis, guaranteeing it as a reliable method of conveying love.

VERTICAL LINES OF SHOCK.............................
Like the vein of anger, this emotional symbol is a unique invention of manga artists. By replacing the eyes with a field of vertical lines, illustrators can convey the sensation of blood draining away from the face. I'm not so sure this one has become as internationally readable as the others on these pages, but I suspect people can understand the idea in an instinctive way.

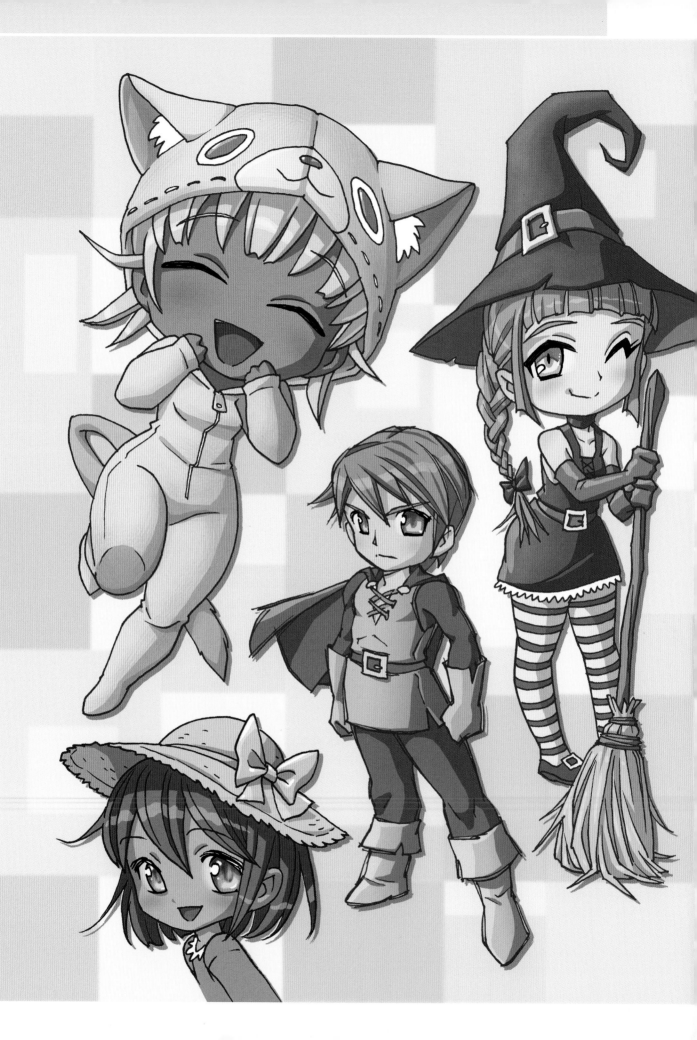

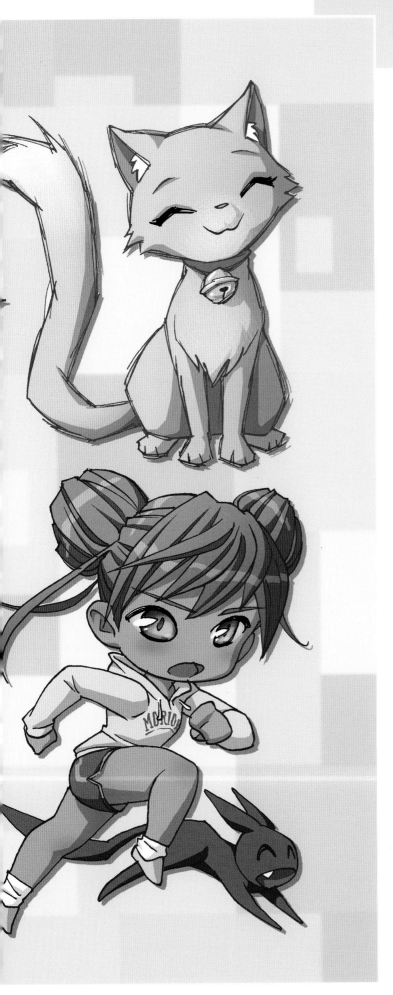

PART 2

Characters and Poses

Once you've figured out the basics of body proportions and facial expressions, you're ready to start taking your chibi drawings to the next level. In this chapter, we'll focus on learning dynamic poses that get your chibis leaping off the page. But we won't stop there. Let's see what happens when fantasy characters and animals get the chibi treatment!

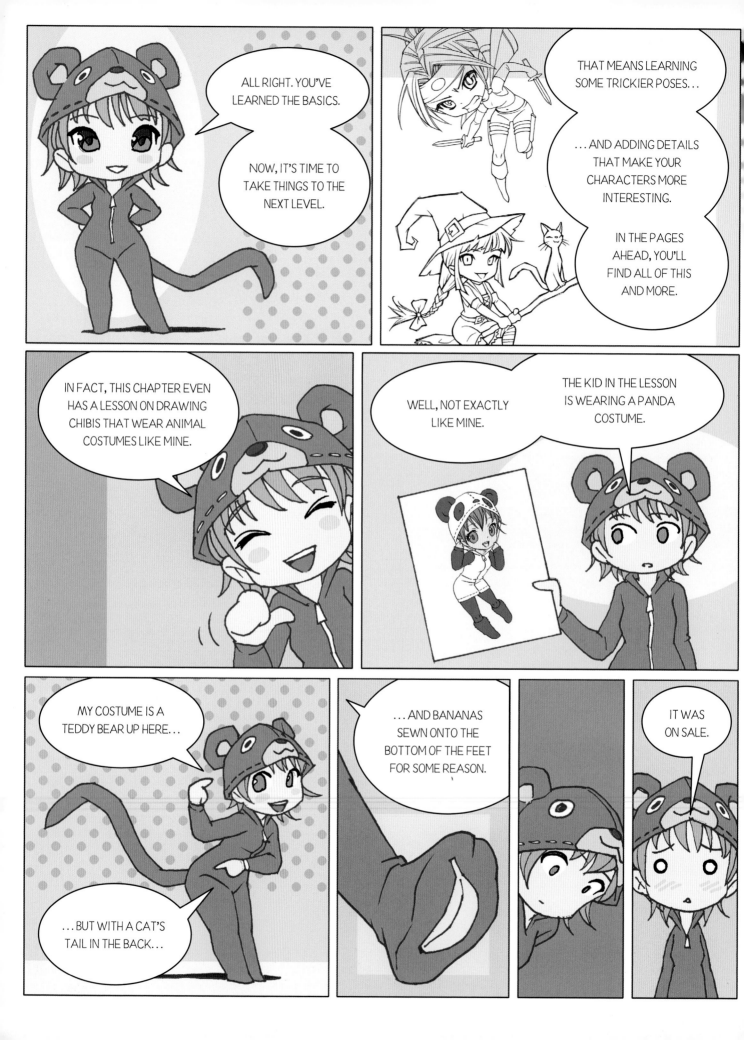

SAME POSE, DIFFERENT CHARACTER

Any pose you learn in this book can be used to create an endless variety of characters. Most artists who are skilled at drawing chibis have memorized poses that they can draw at will, any time they like. Once you've worked out the pose, you are free to turn it into a specific character.

Here you can see how the exact same pose can be used to create two radically different looking drawings. The clothing and hair have changed, but everything else—including the facial features—is identical.

Now, it's your turn. Take one of the poses you've learned in a previous lesson and change the hair and clothing. See just how far you can alter every detail to create an entirely new character!

Running Chibi

Let's begin our exploration of drawing chibi characters by bringing together all the different topics we've learned so far: body proportions, emotions and memorable poses. Many of the poses so far have been standing poses, so let's take on the challenge of a pose that's more dynamic—someone running at top speed.

To make it more specific and fun, imagine our character is late for school. This way it will seem less like a generic running pose and more like a scene from an actual story.

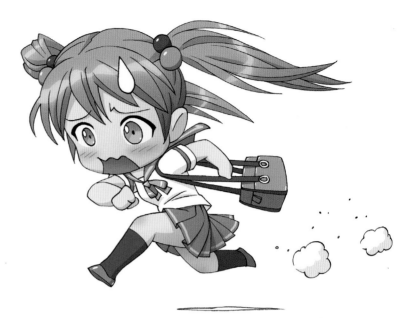

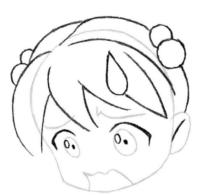

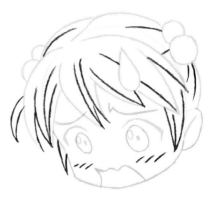

1 Draw the Head Shape and Facial Features

Here the face is seen from a three-quarter point of view. When you draw the head shape, make sure you get a bit of an angle at the bottom of the cheek on the left-hand side. To give our character a worried look, add eyebrows that curve upward, indicating vulnerability. Note that the lines at the bottom of the mouth join with the contour of the head, a playful trick that allows the mouth to be extra large.

2 Draw Hair and Add Details to the Eyes

To add to her panicked look, draw the upper eyelash lines so that they don't touch the tops of her irises. This makes the eyes look wide open and on high alert. Add a couple of decorative elements at the upper left and right of her hair. Later you'll add pigtails to this area. Note the addition of a classic chibi sweat drop. No question: She's frantic!

3 Add the Hair Details

When adding extra lines to the hair near the top of the head, make them curve toward the spots where the pigtails will be added in Step 4. To make her seem like she's gone red in the face, add a few diagonal blushies on both of her cheeks.

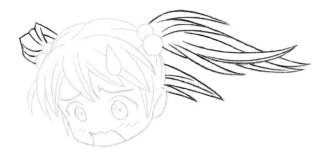

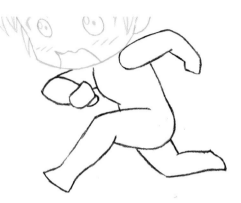

4. Draw the Pigtails

In this drawing, the pigtails are more than just a hairstyle choice. By drawing them suspended in air behind her head, you can help to accentuate the speed at which she's running. The base form of each pigtail is a sort of carrot shape with extra strands of hair added on top. Be sure to make the lines curve toward the points where the pigtails join the head.

5. Draw the Body

Take your time on this step, paying close attention to the angles of each line and the spaces between them. Note that her whole body is shifted over to the right in relation to her head. The angles of the elbows and knees are particularly important. No need to strive for accurate anatomy. Embrace the cartooniness!

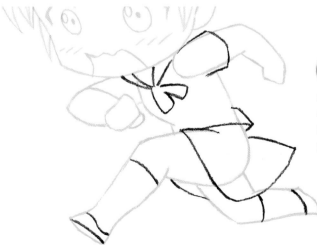

6. Draw the Clothing Basics

I've decided to give this character a high school sailor suit uniform, but as always, there is no need to make the same clothing choices I have. Note that the skirt flows back from her body, adding to the sense of forward momentum. Similarly, her top lifts off her body a bit in the lower back area.

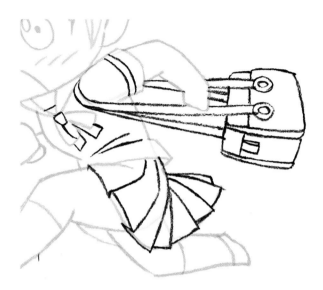

7 Draw the Clothing Details

To accentuate her forward speed even further, I chose to add a bag over her shoulder, having it fly back into the air as if she's been fired from a rocket. If drawing her bag is giving you trouble, simplify it or skip it. It's not essential. Note that the pleats of the skirt curve toward her waist, fanning out as they lead down to the hem.

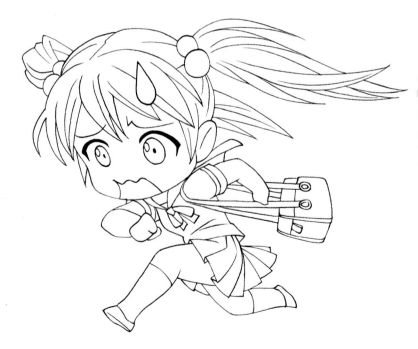

8 Ink the Drawing

Grab your pen and ink over all the lines. Once you've let the ink dry, erase the pencil work. Nicely done! You've definitely taken your chibi drawing abilities to the next level with this dynamic pose.

LINE QUALITY

Every artist finds his or her own way of drawing lines. In many ways, you don't even have to try to be different from other artists. Your lines will be a unique expression of who you are no matter what. Still, many artists go through a period of experimenting with different types of lines before settling on the method they like best. Here are four types of lines you might want to try. These are by no means the only methods. Indeed, there are as many different ways of drawing lines as there are artists on the planet. Experiment and find the ways that look best to you.

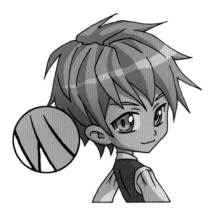

UNIFORMLY THIN..

If you like a light, elegant look, in which the linework calls as little attention to itself as possible, this might be just the one for you. The lines blend into the artwork, allowing the colors and shading to be the star.

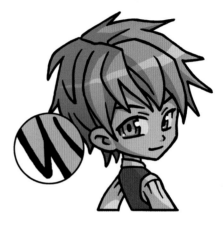

UNIFORMLY THICK..

A line like this can be achieved by pressing down consistently hard on the pen at all times. Alternatively, you can simply use a pen with a thick tip that is capable of producing only thick lines. The final effect is bold and memorable, projecting a sense of artistic confidence.

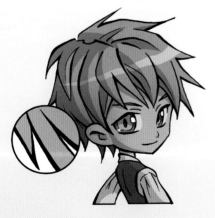

VARYING THICKNESS..

Many artists prefer lines that vary in thickness, often within a single stroke. When you press down hard on your pen, the line gets thicker. When you let up the pressure, allowing the pen to barely touch the page, the line can get very thin indeed.

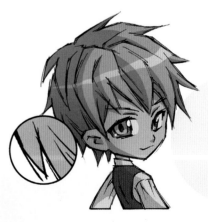

SCRATCHY..

In this approach multiple lines overlap in the same area, creating a more tentative feeling. It seems less perfect, but that's part of the charm. The humanity of the artist comes through in the result.

Action Pose

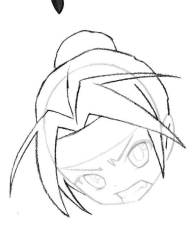

Just because the chibi style lends itself so well to cuteness doesn't mean that every chibi character has to be harmless and cuddly. For this lesson let's see what happens when we take the "big head, small body" approach and apply it to a fierce warrior.

When drawing action poses, I always focus on the angles. Each arm and leg should be slicing through space in a different way, yet all of it needs to work together as a balanced whole. The two-fisted fighter in this lesson can teach us a lot about how it all works.

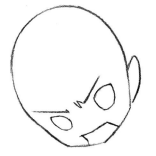

1 Draw the Head Shape and Facial Features

When drawing the head, take care to make it sharply tilted to the left, creating a look of determination. The facial features are quite low on the head, occupying less than half the space available. Again, the bottom of the mouth joins the contour line of the chin. Remember the eyebrow zigzag from the Angry Chibi lesson? Here it is again, indicating a furrowed brow.

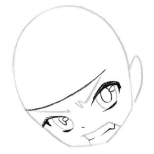

2 Add Details to the Facial Features

While chibi characters are often drawn without lower eyelids, adding them here helps put a squint of determination into this warrior's eyes. Drawing a line across the mouth area creates the appearance of gritted teeth, including a hint of a tough-looking fang on one side. Add a curving line across her lower forehead to get a start on the headband.

3 Draw the Structure of the Hair

I figured an action hero like this one would need her hair pulled back into a bun to keep it from interfering during battle. A single curving line across the crown of the head helps organize the hairstyle into two sides.

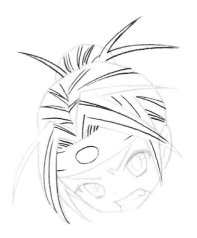

4. Add the Hair Details

I've chosen to add a lot of extra lines here, but you could opt for fewer. The same principles apply: The lines should follow the structure you established in Step 3, curving across the scalp in a way that reveals its form. A few stray strands of hair near the bun add visual interest. Drawing a few small wrinkles on the headband helps give it a clothlike appearance.

5. Draw the Body

As I like to say, it's all about the angles. Her whole body is shifted drastically off to one side, so you need to pay attention to where the body lines join the contour of the head. By having the lower half of the body pointing in a different direction from the upper half, you can project the feeling that she's tensed and pushing herself to the limit.

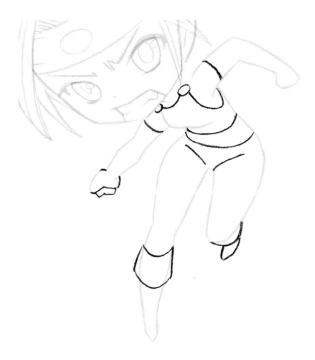

6. Draw the Clothing Basics

As always, feel free to alter the clothing design according to your own tastes. Her right hand is facing toward the viewer, so let's add some lines there to suggest the structure of her clenched fist. Any clothing lines you draw across her body—at the waist, for example—should curve to follow the body's form.

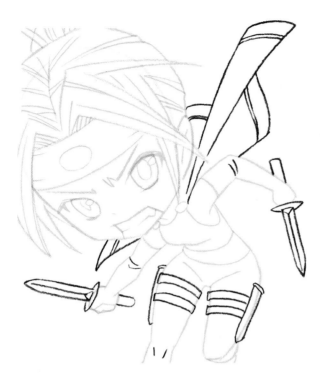

7 Add Clothing Details and Weapons

By drawing a knife in each hand, we naturally make her look tough, but it also adds more dramatic angles, further accentuating the dynamism of the image. With the addition of the cape, we get yet another element that is heading in its own direction. I'm not sure these thigh holsters really make sense as a place to keep knives, but, hey, they look cool!

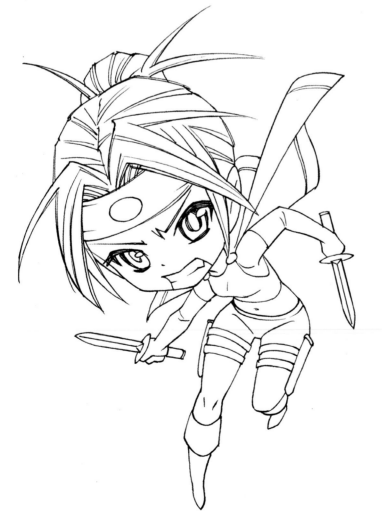

8 Ink the Drawing

Take your favorite pen and ink over all the lines. Give the ink some time to dry, then erase the pencil work.

Hats off to you! You've drawn the most energetic pose in the book so far. If you were able to handle this one, I'd say you're ready for anything else waiting in the lessons ahead.

CHIBI FEET: BIG OR SMALL?

Chibi artists tend to agree on the basics: big head, small body. But when it comes to drawing the feet, paths can diverge quite sharply. I would say the vast majority of chibi characters are drawn with very small feet, minimized even in proportion to the little legs they're attached to. Still, many artists don't follow the rest of the herd in this regard. Here is a comparison of the same character, drawn with feet of three different sizes.

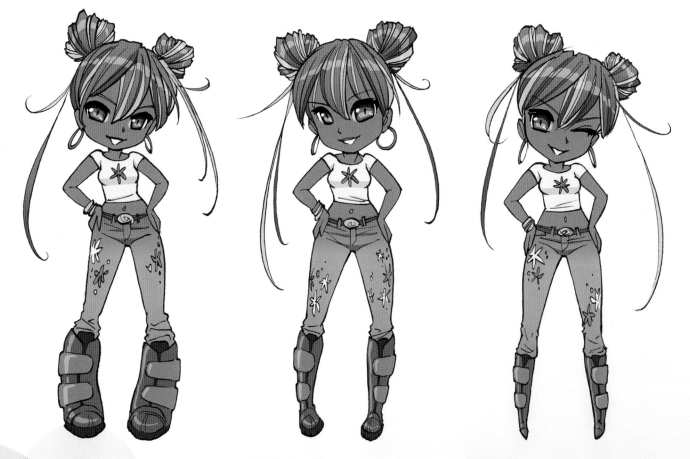

LARGE FEET..............................
You need only look at any other chibi character in this book to see that these feet qualify as clodhoppers by comparison! But, there is an undeniable appeal in this approach: The stance becomes solid and confident, and our character seems incapable of being knocked off balance.

MEDIUM FEET..............................
You might be tempted to say this character approximates real human anatomy, but it's not as simple as that. Her feet are actually quite small, even in comparison to her legs. But, by chibi standards, this reads as conventional proportions. Neither big nor small.

TINY FEET..............................
Now we enter the realm of wild exaggeration, in which even a Barbie doll might say, "With feet like that, you're going to fall over." But chibi drawings are all about bold stylistic choices. Artists who opt for this look clearly are unconcerned with the constraints of real-world proportions. "It's a cartoon," they might say. "It's not supposed to look like a real human being."

Kissing Pose

When I first decided to do a drawing book focused on chibis, I knew right away there would need to be a section devoted to romance. Something about the innocence and lightheartedness of the chibi style lends itself perfectly to drawing characters falling in love.

In this lesson you'll learn to draw two characters kissing. At the same time, it can also serve as a tutorial about drawing chibi faces in profile, since it involves two characters viewed from the side.

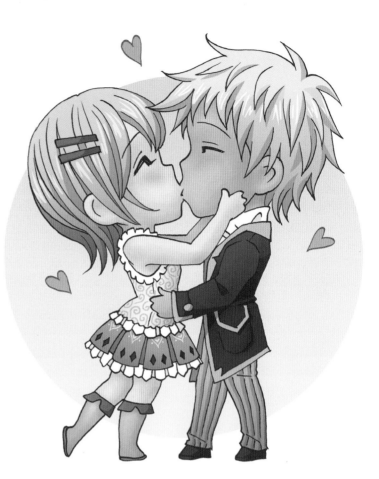

1 Draw the Basic Head Shapes and Facial Features

Chibi faces in profile are greatly simplified from what one sees in real life. When drawing these two head shapes, pay attention to the distance from the tip of the nose to the point of the chin. It is well under half the height of the head as a whole. The angle of the eyebrows and their distance from the eyes shows us that these characters are content and free of worry.

2 Add the Lips and Other Facial Details

Drawing the kiss itself can be tricky, so I've tried to zoom in here to show you the arrangement of lines I've used. Note how there are little gaps in the lines, bringing a lightness of touch to the drawing. Now is a good time to add eyelid folds and structural lines for the ears.

3 Draw the Structure of the Hair

To add visual interest to the image, I've chosen to give our characters different types of hair. Hers is straight and lies flat on her head, while his is spiky and untamed. In both hairstyles, though, the lines are far from random. They curve in a systematic way, each revealing the surface of the head beneath.

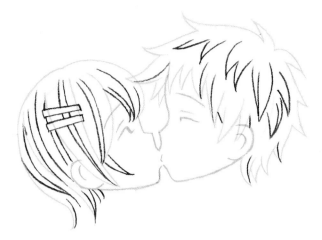

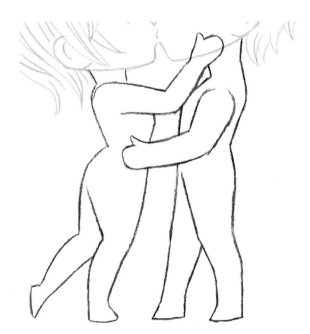

4 Add Details to the Hair

Now that the basic hair structures have been established, you can refine things a bit with extra strands of hair. Add more or fewer lines, depending on your stylistic preferences. I decided to put a couple clips in her hair for an added decorative touch.

5 Draw the Bodies

This may be the most challenging step of any lesson thus far, so take your time, paying close attention to the angle and length of every line before you draw it. Note how her arm is a loose mirror of his, bending at the elbow in much the same way. If you're having trouble drawing her upper legs or his, no need to concern yourself too much. They will be largely concealed by clothing in the next step.

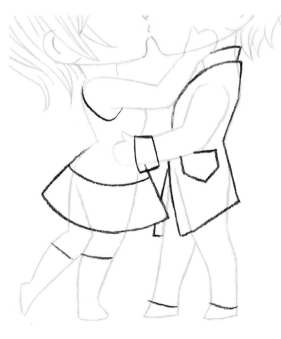

6 Draw the Clothing Basics

The clothing can be as fancy and elaborate as you like. But it's always best to begin with the basic forms before getting into details. By curving the bottom contour line of her skirt, it becomes more three-dimensional than if you were to make the line perfectly straight.

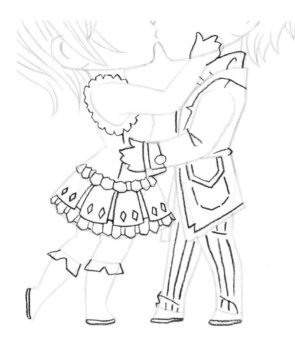

7 Add Clothing Details

Just because I decided to have our two lovebirds dressed to the nines doesn't mean you have to get quite so extravagant. Include as many or as few of these details as you like. Just take care to have any ornamentation you draw follow the structure established in the previous step. The diamond shapes on her skirt, for example, are carefully placed to follow the curved lines we drew in Step 6.

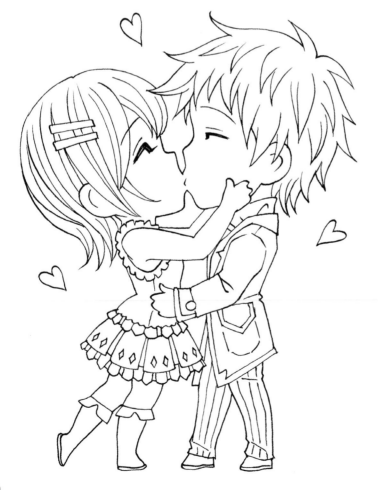

8 Ink the Drawing

You know what to do: Grab that pen and carefully ink all the lines. After the ink has dried, erase the pencil lines.

There you have it! A chibi couple in love. Want to use this pose for a drawing you give to someone as a wedding gift? Have at it! That's just the kind of thing I had in mind when I came up with it.

ROMANTIC CHIBI POSES

The chibi style is all about bringing the cute, so when you draw chibis in love, you'll want a wide variety of adorable poses to put your characters into. Here are a few such poses to get you started.

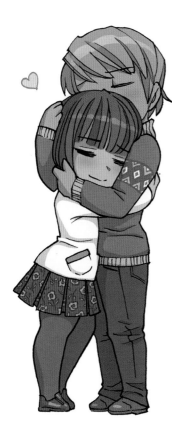

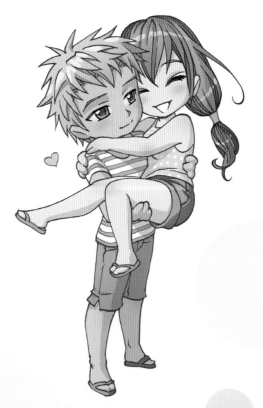

KISS ON THE FOREHEAD..
Sure, a kiss on the lips is the first type of kiss we tend to think of. But there is something very warm and tender about a kiss on the forehead. If you've never drawn such a pose, now's your chance!

GENTLE HUG..
When it comes to hugs, it's definitely easier to give one than to draw one. If you get confused about what your characters should look like when they're hugging, consult this picture for ideas. Notice how her head naturally blocks much of his face from view.

UP IN ARMS..
Maybe the most challenging romantic pose of them all is that of one character carrying another. And it's no wonder. So many arms and legs to keep track of! Never fear, this drawing can help you get the basic pose in place with minimal struggle.

Witch Chibi

Chibi characters are, by their very nature, a little unreal. The big heads, the tiny bodies, the giant sweat drops—they belong more to the realm of the imagination than to the humdrum world real people live in. Because of this, the chibi style is very well suited to depicting supernatural beings.

In this lesson, we'll learn how to draw a chibi witch. Fair warning, this is definitely the most ambitious lesson in the book so far and will require more than the usual amount of patience. But, if you give it your all, you'll be rewarded with an illustration you can really be proud of.

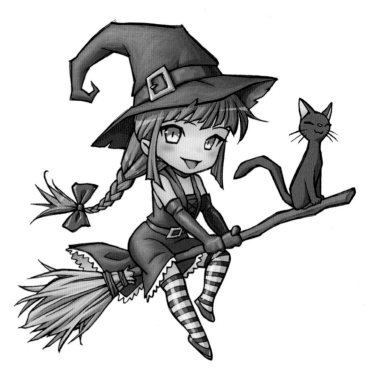

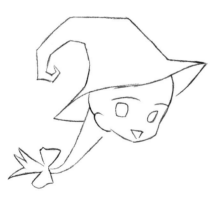

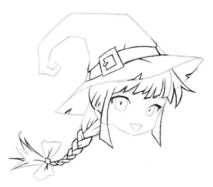

1 Draw the Basic Head and Hat Shapes

Begin by drawing the head shape, then add the hat shape on top of it. Note that the opening at the bottom of the hat covers no more than the top third of the head. I made the hat curl in at the tip, but feel free to make it straighter if you prefer. If you'd like to give her a braided ponytail as I did, draw that basic shape now, making it join the head behind the ear.

2 Add the Details of the Hat, Hair and Facial Features

A buckle strap across the hat can be a nice detail. Note how it curves, helping us see the hat as rounded rather than flat. I decided to make the pupils super tiny to give our witch a cat-eyed look. Take your time with the hair, simplifying it if you need to. For extra guidance on drawing the braid, consult the step-by-step lesson that follows this demonstration.

3 Draw the Body

When drawing her body, note how both the arms and one of the legs are all roughly at the same angle, parallel to one another. Her hands look like little boxes, and for chibis that is often enough. Proportionally, the entire body from shoulder to toe is similar to the size of the hat. Pay attention to the thickness of the legs compared to the arms.

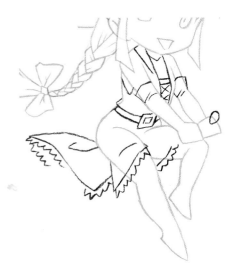

4 Add the Clothing

Now that you have the structure of the body in place, you can dress her in any clothes you like. I gave her elbow-length gloves and a belt around the waist that resembles the buckle on her hat. Since she'll be flying on a broom, I made her dress flap behind her in the wind. Oh, and don't forget the thumb on her left hand. She's gonna need that to keep a good grip on the broomstick!

5 Draw the Basic Shape of the Cat

Draw the front part of the broomstick, taking care to make its angle match the angle of her two hands. I've made the broomstick deliberately crooked just for fun.

Draw the basic shape of the cat. At this stage it's enough to draw the head as a small circle and the ears as triangles. Take care when drawing the cat's body shape to make it taper a bit as it nears the head.

6 Draw the Details of the Cat

With the cat's body shape established, add all the details. A diagonal line on each ear helps convey the structure. In this cartoony style the eyes and the nose line up with each other. An S-shaped tail is an essential finishing touch, as is the addition of a few whiskers on each side of the face.

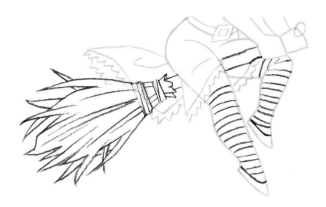

7 Add Broomstick Details and Stocking Stripes

When completing the broomstick, start at the bottom of her hand, making sure the segments line up to read as a single piece of wood. Feel free to simplify the bottom part of the broom if you like. I chose to give it a rustic look, with corn husks held in place by two tightly bound lengths of rope. When adding stripes to the stockings, make them curve a bit to reveal the shape of her legs beneath them.

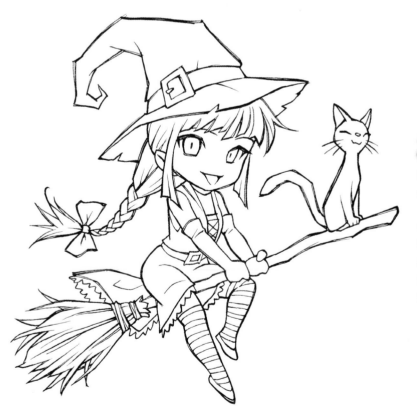

8 Ink the Drawing

At last, you can grab your pen and ink all the lines. Once the ink has dried, erase all the pencil lines.

A drawing with multiple elements—witch, cat and broom, in this case—always takes a little extra time. But rather than avoid such challenges, it's important to take them on every once in a while so that you may grow as an artist.

Drawing Braids

Different hairstyles present different drawing challenges, but, when it comes to complexity, nothing beats braids. Where the heck are all those lines supposed to go? I found the whole thing so tricky, I finally sat down and came up with a simple method I could use to draw decent-looking braids every single time. Read on to discover the secret.

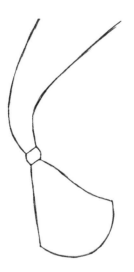
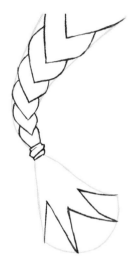
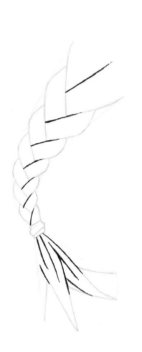
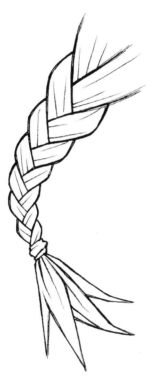

1 Draw the Basic Outline

Start by drawing a simple outline of the braid. Most braids are wider at the top and gradually narrow as they reach the spot where they are bound by an elastic band. Indicate the base of the braid with a simple cone shape.

2 Add Interlocking V Shapes

Starting near the elastic band, draw a series of thick V shapes, one resting upon the other. To get the best result, make one side of the V slightly longer than the other (in my example, the left side). Add a zigzagging line at the bottom for the loose, unbraided hair.

3 Change the V Shapes Into Braids

Add a series of diagonal lines that split each V shape into two halves. As if by magic, the V shapes begin to look like braids. Extra lines in the area of loose hair are a final detail that makes the drawing more natural.

4 Ink the Lines

Grab your pen and ink all the lines. If you want to, you can add an extra line or two within each braid, to help convey the directional flow of the hair. Let the ink dry, then carefully erase all the pencil lines. So there you have it: the secret to drawing good braids!

Panda Girl Chibi

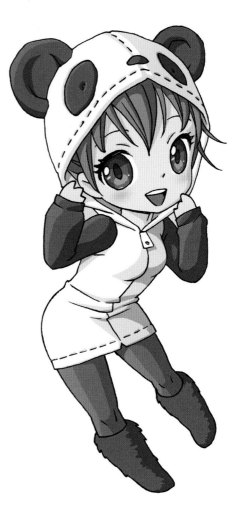

Artists who draw chibis don't want to get stuck drawing the same character over and over again. They're always on the lookout for little tricks that allow them to draw their chibis in new ways. One of my favorite methods of doing something new with an old familiar face is to draw the character wearing an animal costume.

In this lesson, we'll draw a chibi girl wearing a panda costume. While following along with the various steps, try thinking of other animal costumes you could draw later on. I mean, pandas are cute, sure. But there's a whole zoo's worth of animals out there that you could try next.

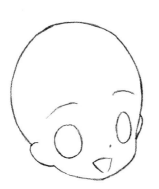

1 Draw the Head Shape and Facial Features

When drawing the head, pay attention to the contour on the right side. It snakes around the cheek in a way that is unique to the three-quarter point of view. The eyes, nose and mouth are confined to the lower third of the head. Don't forget the space between the eyes. It's always a crucial part of the facial proportions.

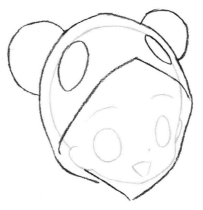

2 Add the Shape of the Panda Hoodie

Begin by drawing a curving line above the head that follows the line of the scalp. Then add an upside-down V-shaped line across the forehead to serve as the opening of the hoodie. When drawing the panda eye circles, compress the one on the right into a narrow oval to show it's turning away from us. For now, the panda ears are simple half-circles, widely spaced.

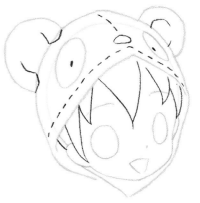

3 Draw the Hoodie Details

Refine the shape of the ears, adding structural lines that make them appear slightly donut-like in form. The panda eyes are mere dots, but pay attention to their placement within the eye circles. Add stitching lines above the nose and across the hoodie's edge to give the costume a hand-sewn look. Get the basics of the hairstyle in place, altering it as you please.

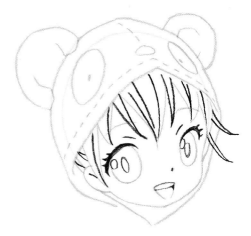

4 Add Details to the Hair and Eyes

Whatever hairstyle you choose to draw, it's always best to get a basic contour in place before adding extra lines and details like the stray strands you see here. Noses are always optional with chibi characters. I've decided to add a little dot of a nose to this character. Narrow oval-shaped pupils add to this panda-girl's cute and innocent look.

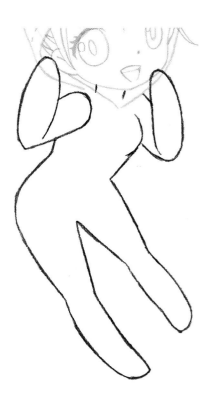

5 Draw the Basic Shape of the Body

A great trick for avoiding the dullness of a *just standing there* pose is to have your chibi character's torso pointing in a different direction than the legs. It adds liveliness and energy to the drawing. Note that the forearms are quite vertical here, allowing her hands to slightly overlap her head in a way that adds cuteness to the pose.

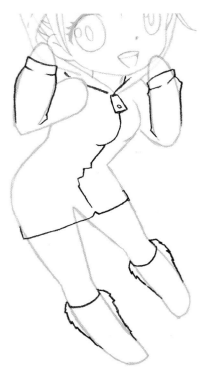

6 Draw the Clothing Basics

Add the hoodie dress, allowing it to closely follow the form of the body in most places. Near the cuffs, I've altered the contour to make the sleeves puff out a bit. The line of the zipper is a structural detail that helps us see how the clothing stretches across the body. I decided to make the boots super furry to complete the panda look.

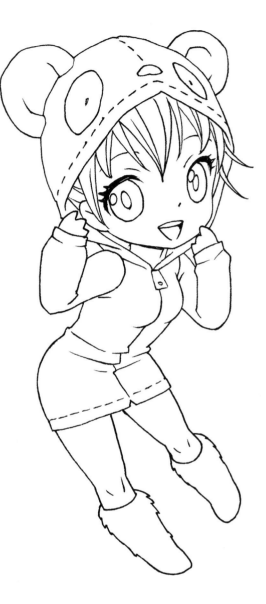

7 Draw the Hands, Knees and Clothing Details

You can refine the hands into individual fingers, but remember that chibi fingers are usually very short and stubby. A number of curving horizontal lines at the waist helps convey wrinkles in the clothing. I added stitching lines along the hem of the skirt to match the hoodie. And it never hurts to draw a couple lines on the legs to add structure to the knees.

8 Ink the Drawing

You know the drill, get your pen and ink all those lines. After the ink has dried, you can erase all the pencil work.

Many of the illustrations in this book benefit from a splash of added color, but with a panda costume you can get away with just black and white. In fact, it's kind of a requirement!

ANATOMY OF A CHIBI EYE

There are countless ways of drawing chibi eyes, but most of them share certain elements. Use this chart to learn the crucial components and what role each of them plays in giving the chibi eye its distinctive look.

Highlight | Most chibi eyes have at least one highlight, the little white dots that make the iris appear shiny. Typically the biggest highlight is located near the top of the iris.

Eyelid Fold | While not absolutely essential, an indication of the eyelid fold is quite common in chibi eyes.

Upper Eyelash | A strong upper eyelash is a crucial part of almost every chibi eye. Some artists will add a few individual lashes, but it's very common for the whole thing to be a single crescent-shaped area of black, as you see here.

Iris | When it comes to chibi eyes, the iris is really the star of the show. The gradations of color can be quite spectacular, depending on how much time you want to put into the coloring process. It's very common for the upper half of the iris to be darker than the lower half. While some artists will add a small line for the lower eyelash, others will simply flatten the lower edge of the iris (as you see here) to suggest the lower eyelash's presence without actually drawing it.

Pupil | Chibi pupils come in all shapes and sizes. In real life the human pupil is jet black and perfectly round. In chibi eyes the pupil is sometimes an oval shape and can be any color the artist chooses.

Fox Boy Chibi

Drawing chibis wearing animal costumes is fun, but there's another chibi tradition that takes this idea further: drawing human chibis that have one or two actual animal attributes. Typically these chibis have the ears and tail of a particular animal, such as cat girls, rabbit boys and so on.

In this lesson, we'll be drawing a fox boy. You'll learn how to draw the ears and the tail, of course, but also get in some more practice drawing fancy clothes as this character is a bit of a dapper dresser.

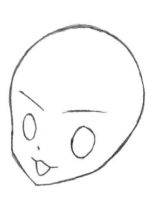

1 Draw the Head Shape and Facial Features

This head shape resembles many of the ones you've drawn already, with one key difference: the upper lip. It is drawn to resemble that of a fox, divided into two sections. This head is turned to the left, so the eye on the left side of the face is reduced in size, indicating that it's farther from us than the one on the right.

2 Add the Ear Shapes and Eye Details

Draw the contours of the ears, taking care to make them point outward rather than straight up. They are triangular in shape but curve out a bit at the base. Add eyelashes, eyelid folds and details in the irises, such as pupils and highlights. I opted for tiny pupils, creating an animal-like effect.

3 Draw the Basic Hair Shape and Ear Structure

Add a diagonal line to each ear, dividing the spaces into an upper surface and a lower interior surface. Then draw guidelines for the hair that flows down from the crown on the head.

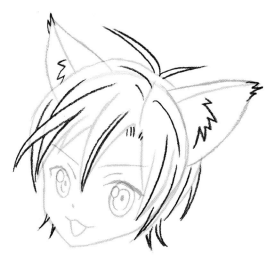

4 Add the Ear and Hair Details

Once the basic structure of the hair is in place, you can add details, such as extra lines here and there and little stray strands of hair that go off in different directions. A couple of zigzagging lines in each ear can suggest the presence of fur.

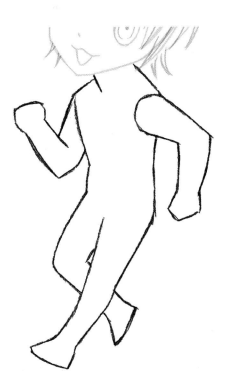

5 Draw the Body

Draw the basic lines of the body. I've opted for a trotting pose, which calls for contrasting positions between the two arms. On the left, the fist points up, while on the right, it points down. Similarly, one of the legs is bent at the knee, while the other is straight.

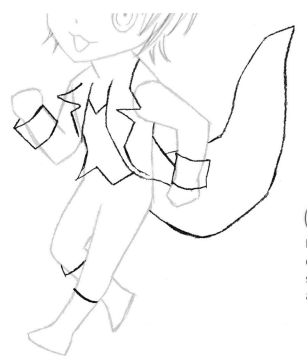

6 Add the Clothing Structure and Tail

For a formal look, add a jacket with cuffs and a vest. By making the back of the jacket rise up off the body, you can suggest that he is on the move. When drawing the basic shape of the tail, note its size relative to his body: It's at least as large as both his legs put together.

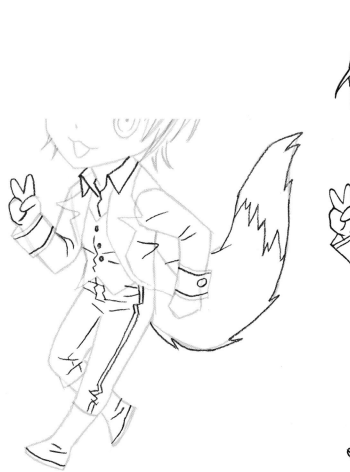

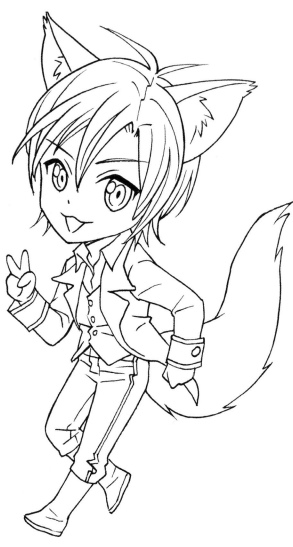

7 Add the Details of the Clothing, Hand and Tail

The final step is to add clothing details, such as his collar and a stripe down his pant leg. Most of the clothing folds and wrinkles stretch horizontally across his arms, waist and legs. Changing the contour of his tail to a zigzagging line adds furriness. Can't have a foxtail without fur!

8 Ink the Drawing

Take your pen and ink over all the lines. After the ink has dried, erase all the pencil work. Now that you've drawn fox ears on a character, maybe you're curious about how to add cat ears or dog ears to a character. Read on, the info you need is coming up next.

ADDING ANIMAL FEATURES

Any chibi character can be turned into a hybrid character by adding the ears and tail of a particular animal. But where do the ears go? Where do you place the tail? Compare these two images to see how an ordinary girl can be transformed into a cat girl.

EAR AND TAIL PLACEMENT...
While we might imagine the ears as standing straight up on the top of the head, manga artists tend to draw them a little more over to the edges, extending from either side of the head at a 45-degree angle.

DOG EARS..
It can be hard to see the difference between the shapes of cat ears and dog ears in a drawing. One way to make the difference clearer is to draw dog ears flopping down instead of pointing up. Since no cat ears ever take on this floppy look, the viewer will always see this shape as the ears of a dog.

CLOTHING WRINKLES

Drawing clothing can be tricky for any artist, whether the picture's done in the chibi style or not. Where exactly do all those extra lines go? If you start tossing them into the drawing at random, you'll end up turning things into a mess.

To help you get a handle on this tricky subject, here's a chibi character before and after the addition of clothing wrinkles.

NO WRINKLES...........................
Depending on your preference, this version may be fully acceptable. But if you want the clothing to look less stiff, you'll definitely want to add some wrinkles.

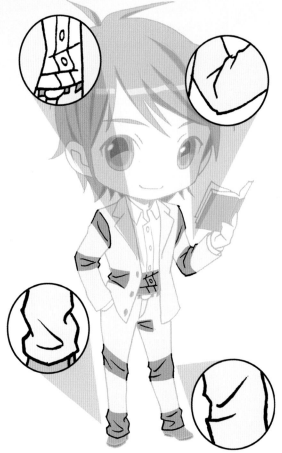

THE WRINKLE ZONES.....................
Here you can see the key areas where wrinkles tend to form: the upper arm, elbow, waist, knees and ankles. In each area, the lines stretch across the fabric in a roughly horizontal direction.

WRINKLES ADDED...............................
Here's the final effect once the wrinkles are in place. The clothing looks softer and much more natural. Next time you're confused about where to draw wrinkles on a character's clothing, come back to this page for guidance.

CLOTHING THROUGH THE SEASONS

Clothing has a natural relationship with the seasons of the year, but as an artist you can lose sight of this and end up drawing your chibi characters dressed the same way most of the time. One great way to break out of this rut is to try drawing the same character dressed differently for each of the four seasons.

SUMMER..

We all know what classic summer clothing looks like. But don't forget the importance of warm colors such as yellow and orange.

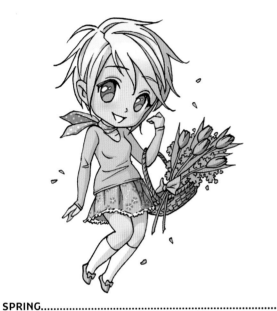

SPRING...

Floral patterns and pastel colors can go a long way toward conveying spring. Go for a light and innocent vibe.

WINTER..

Items such as scarves and hats guarantee a cold-weather look for your character. Choosing cold colors, like this chilly blue, can add to the wintery effect.

AUTUMN...

When the leaves start to fall, out come the browns and ochres. A layered look, like a vest on top of a turtleneck, helps signal the change of seasons.

ACCESSORIES

When you're drawing chibis, one of your goals is to make the characters distinctive. One way to add individuality to a chibi you've created is to give her interesting accessories, items that tell us a little about who she is. Here are a few examples.

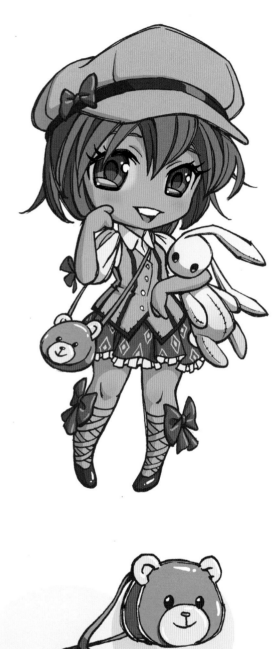

HATS..
A hat is a simple way to set your chibis apart. I wanted this girl to have a youthful and peppy look, so I chose this variation on a newsboy cap.

DOLLS..
Many artists will draw chibis with a sort of stuffed-doll mascot that becomes a visual trademark for them. Of course, this gives you a whole new item that needs to be designed from scratch. But, if you're like me, you'll enjoy the challenge, and it's guaranteed to make your character stand out in a big way.

PURSES..
A purse can be an important extension of someone's style sense. There are an infinite variety of purse styles, each projecting a slightly different message about the person carrying it. I decided to go all in on the cute factor with this teddy bear purse, but your character may require something a little more grown-up.

SIMPLIFYING OBJECTS

Drawing chibis involves dispensing with the details of real human anatomy and replacing them with something charming and simple. So when you draw your chibis interacting with objects, you can put those objects through a similar process of simplification. As an example, here's how I would "chibi-fy" a motorcycle to make it visually match its rider.

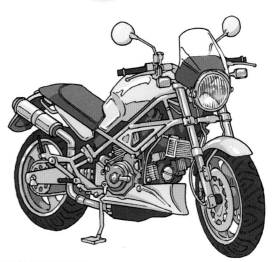

REAL MOTORCYCLE...
Real-world machinery can be insanely detailed. If I were to draw a chibi character sitting on a motorcycle like the one drawn here, the clash of styles would be visually jarring. To create a more harmonious illustration, I must reduce the motorcycle to its core elements.

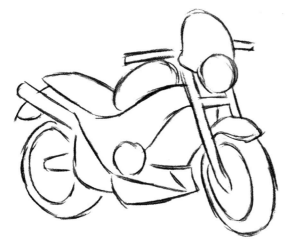

SIMPLE SKETCH...
By allowing myself to ignore the details, I roughly sketch out a sort of symbol of a motorcycle—inaccurate in terms of the real world, but faithful to the basic shape and proportions of its key structures. By covering up the interior machinery, I can make loads of details vanish entirely.

CHIBI-FIED MOTORCYCLE...
In the finished image, my drawing of the vehicle isn't going to win any prizes from motorcycle geeks. But, it has a certain chibi look to it now, coming across as just right for the guy riding it.

Next time you have to draw a chibi interacting with an item from the real world—be it a desk, a tree or even a house—try this same method of simplification to make the item fit more naturally into the world of chibis.

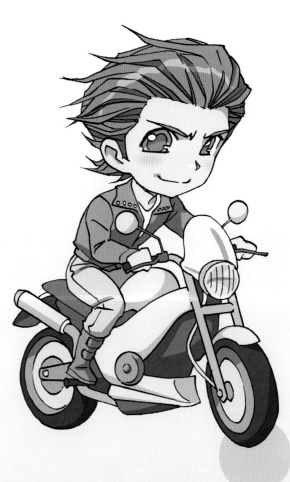

Chibi Dog

Well, you've learned how to draw a chibi wearing an animal costume and a chibi with animal ears. The next logical step is to start drawing actual chibi animals. I was having trouble choosing between a lesson on dogs and a lesson on cats, so I decided to do one of each. Let's start with the dog.

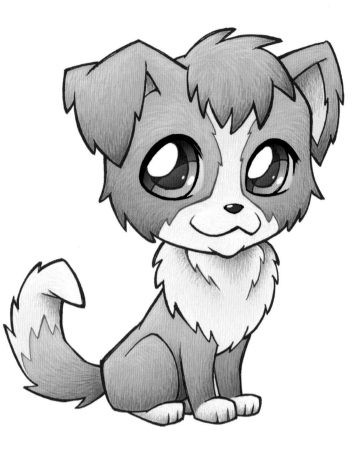

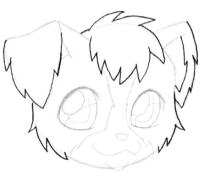

1 Draw the Head Shape and Eyes

Our chibi dog's head shape is pretty close to a circle. However, since we're drawing him in a three-quarter point of view, there are slight angles in the contour on the right, indicating the forehead and cheek. The ears are triangular in shape, pointing down to reveal their floppiness. Note the size of the eyes and their location, a little closer to the bottom of the head than the top.

2 Add the Facial Details

Draw the lines of the nose, mouth and chin. Note that all three combined are around the size of one of the eyes. I've given the eyes extra-large highlights to make them appear super shiny. A couple of zigzagging lines up the middle of the head delineate the changing colors of the fur in that area.

3 Draw the Fur

Change most of the contour lines to zigzags to make the dog's head appear more furry. Note how the V shapes that compose these contour lines point in slightly different directions. I added a nice big ball of fur onto the forehead purely for the sake of cuteness.

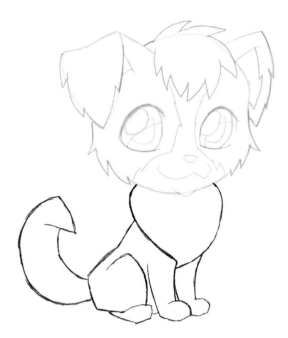

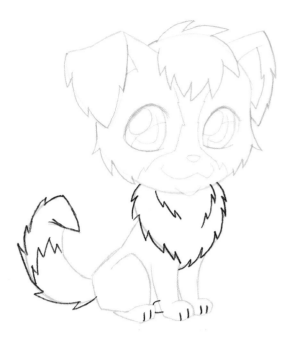

4 Draw the Body and Tail
Take your time with this step, as it is a fairly complex shape. I'd advise starting with the heart-shaped area beneath his chin, then moving on to the legs and saving the tail for last. Note the size of the body in relation to the head: The two are nearly the same size. Take care to make the three visible paws line up with each other, left to right.

5 Add the Fur Details
As with the head, many of the contour lines can be changed to zigzags to convey furriness. Tiny vertical lines on the feet help them to be read as paws. A zigzagging line across the tail can suggest a change of color in that area.

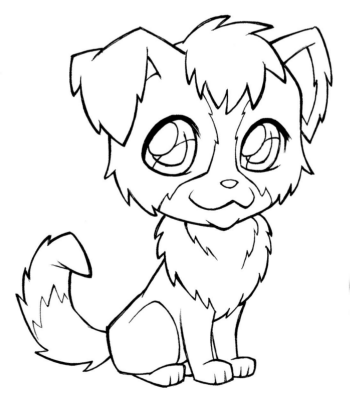

6 Ink the Drawing
Switch to your pen and ink all the lines. Once the ink has dried, you can erase all the pencil guidelines. There you have it: a chibi dog guaranteed to make everyone go, "Daaaw!"

Chibi Cat

Now that the dog lovers have had their chibi lesson, it's the cat people's turn. But really, who's to say you can't be a fan of both? Instead of a sitting pose, let's try one where all four legs are visible.

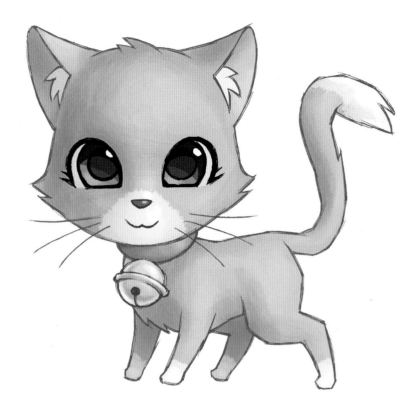

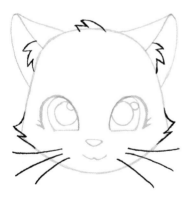

1 Draw the Head Shape, Eyes and Ears

Unlike the dog, our chibi cat has a gumdrop shape for her head. Note the pointy angles on the left and right, and how the top of the head is a little like a helmet. As in previous lessons, the ears point outward diagonally rather than straight up, and the eyes are closer to the bottom of the head than the top.

2 Add the Facial Details and Ear Structure

Add eyelashes to each eye as well as pupils and highlights. I've gone for huge circular pupils, but you may prefer them to be smaller or more oval in shape. Note how small both the nose and the mouth are compared to the eyes. A curving diagonal line across the ears divides them into an upper, exterior surface and a lower, interior one.

3 Draw the Fur and Whiskers

The contours of our kitty's head will remain mostly smooth, but I've added a few zigzagging lines: one atop the forehead, one inside each of the ears and one on both sides of the jaw. This creates a semi-furry effect. Don't forget the whiskers; I've given them each a slight curve and tilted them all downward just a touch.

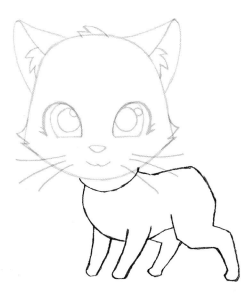

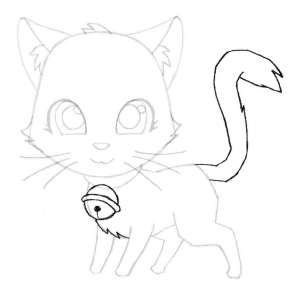

Draw the Body, Collar and Legs
This is probably the most challenging step in the lesson, so take your time. Start with the collar, then draw the basic shape of the body, paying attention to both the shape and the size. The rear leg is a tricky shape to draw. Focus on the angles in the contour lines and on the tapering width as you reach the area of the paws.

Add the Tail and Bell
Adding a bell to the collar is optional, of course. It's so cute, though—why would you skip it? It's a small circle with a curving band across the middle. In the lower half is a black dot with a short line attached. I've chosen an S shape for the tail with a bit of fur indicated at the tip.

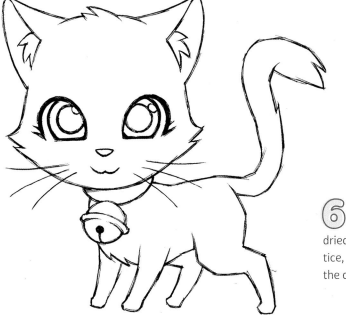

Ink the Drawing
Grab your pen and ink all the lines. Once the ink has dried, you can erase all the pencil guidelines. For extra practice, try reversing the poses of these last two lessons: Draw the dog up on all fours and the cat in a sitting position.

Chibi Robot

Using the chibi approach for any type of character is fun, but I think things get especially interesting when it's applied to unexpected subjects. Anime-style robots, for example, are normally all about being super futuristic and cool-looking. Can they survive a heavy dose of chibi cuteness? Well, there's only one way to find out!

Fair warning: This is among the most challenging lessons in the book. Don't jump into it unless you're ready to take your time moving from one step to the next.

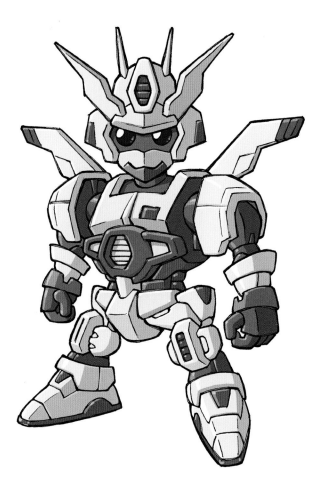

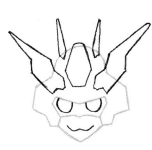

1 Draw the Head Shape
Anime-style robots are known for their exceptional level of detail. Even the basic shapes of the individual body parts are composed of lots of lines and subtle angles. This robot's head is perfectly symmetrical, so do your best to make the left side mirror the right side. Note that the upper edge of the visor serves as a kind of eyebrow, conveying a look of determination.

2 Add the Helmet Details
Here's where you should feel free to make it your own. I've added winglike shapes above each eye, but you may prefer something different. The symmetry should remain, though. Try to avoid one side being noticeably different from the other.

3 Draw the Upper Body Structure
The robot is turning a little to the left, so the arm on the left is reduced in size, making it appear farther away. Anime-style robots generally have some sort of large protective covering over each shoulder. You may choose to make this covering considerably larger in your drawing.

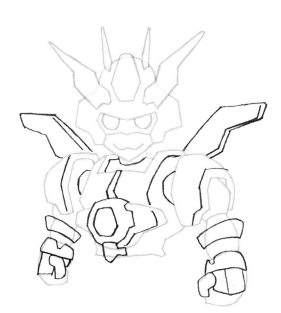

4 Add the Upper Body Details

Once the basic structures are in place, you can add details like wings and banding on the arms. Note how the lines I've added to the shoulder coverings help define the thickness of the armor in that area. For the fists, I've drawn only the thumbs at this stage, leaving the fingers for later.

5 Draw the Lower Body Structure

Here's where things really get chibi-fied: These legs are super short and cartoony. By making the feet point in dramatically different directions, you can increase the perceived confidence of the stance. Feel free to alter all the shapes to suit your own preferences.

6 Add the Lower Body Details

Add lines to the feet to further define their structure. The foot pointing toward the viewer can be particularly challenging, so be patient and concentrate on the angle of each individual line in that area. The goal here is to draw structures that appear solid and three-dimensional.

7 Add the Final Details

Good news: You've completed the hardest part! Now that you've got all the key structures in place, you can add tiny details throughout the drawing. At this stage I'd say perfect symmetry is no longer necessary. If the left side of his chest plate has details that are different from the right side, well, that just makes things more interesting.

8 Ink the Drawing

Given the amount of time needed for this one, you may want to take a little break before getting into the inking. Many anime-style robots have a sleek, smooth surface, which calls for clean, confident strokes of the pen. You can get around this, though, by opting for an aged, rusting look. In this style, less than perfect lines can actually work in your favor.

UNCONVENTIONAL CHIBI STYLES

Different artists have different goals when it comes to drawing chibis. Not everyone wants their artwork to look exactly like the ones seen in Japanese manga. Indeed, in matters of creativity, it is often a good idea to break the rules in search of something new. Here are three examples of chibi drawings that are off the beaten path.

HUGE EYES, TINY FEET...
One way of changing things up stylistically is to start playing around with the proportions. Here, the eyes are gigantic, even by chibi standards. And the arms and legs are super thin and spindly. Some may say, "It's weird," while others respond, "It's different. I like it."

WIDE HEAD, DOTS FOR EYES...
Here we have a kind of bobble-head approach. The face appears wide because the body is so thin. Replacing the eyes with black dots is a bold choice that is somehow both cute and slightly spooky!

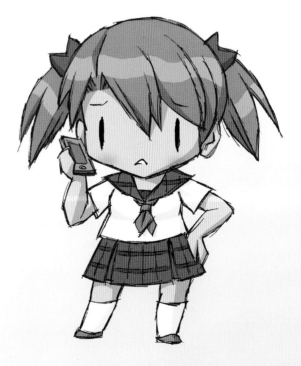

NARROW EYES, SCRATCHY LINES...................................
This one really tosses the whole "manga eyes" thing out the window. The head and body proportions of this chibi are fairly conventional, but the tall, narrow eyes are a dramatic departure from the norm. Deliberately scratchy linework adds to the experimental feel.

FANTASY CHIBIS

One fun way to practice drawing chibis is to draw a chibi version of a fantasy character. We all have an idea of what a mermaid is supposed to look like. But what about a chibi mermaid? On these pages you can see my chibi versions of six popular types of fantasy characters. Here's hoping they inspire you to create drawings of your own.

FAIRY...
For me the true essence of fairies is their ethereal, lighter than air quality. So I made sure to use delicate lines and pastel colors, giving this chibi a wispy, floral feeling.

ELF..
I imagine elves as much more down-to-earth than fairies, so I switched to browns and yellow-greens for my color scheme. I'm not sure many artists draw elf ears pointing out to the sides like this, but I thought this approach made for an interesting silhouette.

MERMAID..
Water is very much the theme here. Both the color choices and the flowing, wavelike hair were meant to give the entire illustration an oceany feeling. I put three highlights in each eye to make them look extra watery.

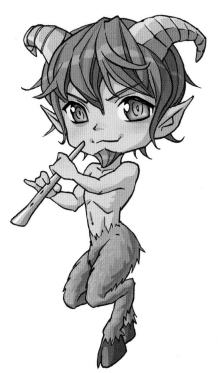

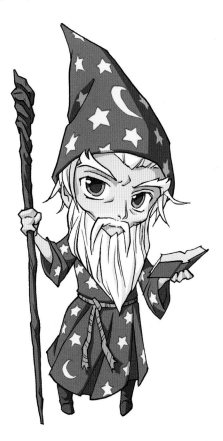

GENIE...
Like her fairy cousin, a genie needs to seem at home in the air. To me, this meant going for twisty, smokelike shapes throughout the image. This time I gave the eyes no pupils at all, creating a glassy, ghostly look.

FAUN...
As with the elf character, earthy colors seemed the natural choice. I imagine fauns as having a playful personality, so I put a slightly mischievous look on his face. To add to his goatlike look, I gave him eyes with big irises but tiny pupils.

WIZARD...
The babyish proportions of chibis make them ideal for drawing youthful characters, so drawing an elderly character like a wizard is a fun change of pace. I knew the classic moon-and-stars cap was a must. This time I made the pupils big and dark to give him an all-seeing look.

Chibi Craft Projects

Now that you've moved beyond the basics, it's time to show your skills to the world. In this chapter, we'll learn ten new chibi poses, but it doesn't stop there. With each pose, you'll be introduced to a new type of craft project, showing how to put your chibis on everything from T-shirts and stickers to posters and buttons.

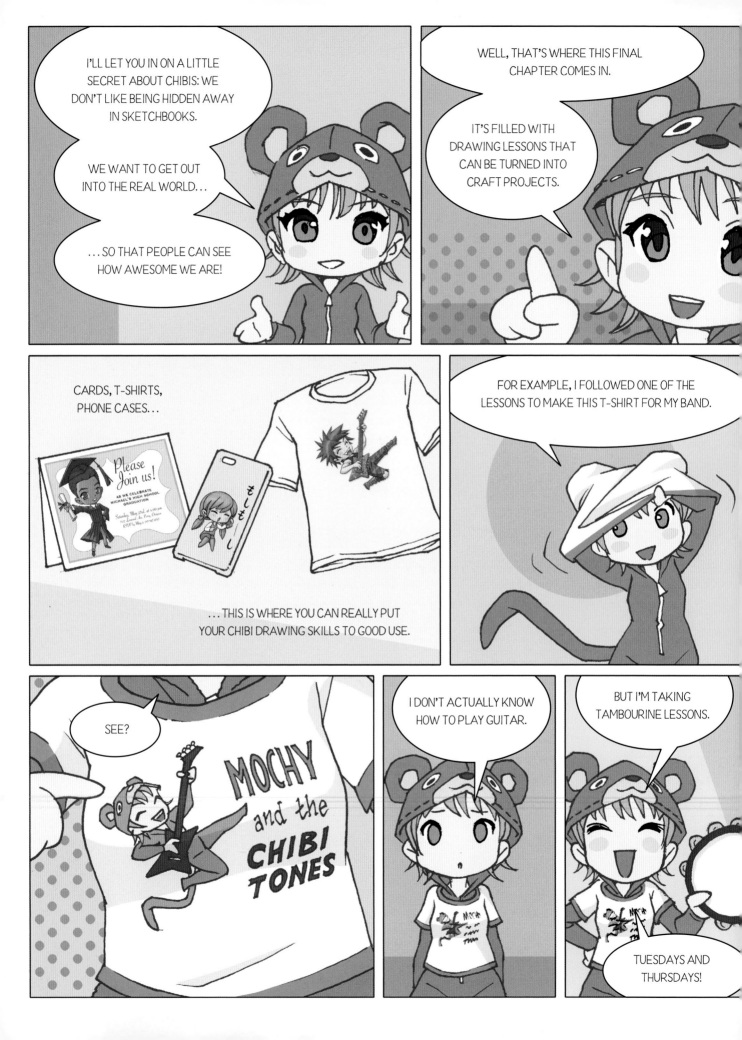

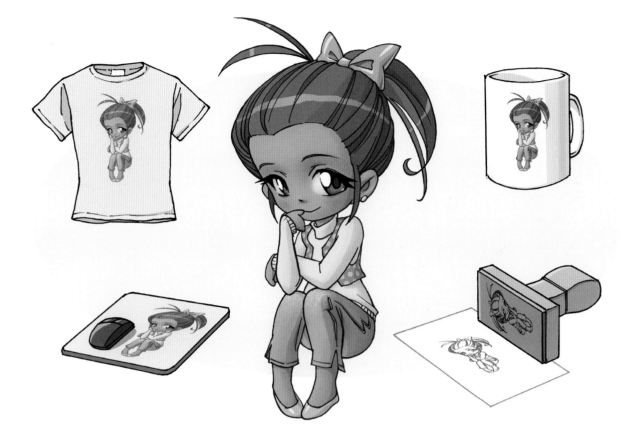

CUSTOM CHIBI GEAR

Chibi characters are uniquely suited for use outside the pages of books. There's something about their bold, simplified style that makes them look good on almost any item. Part of it is the lack of fussy details. You can shrink a chibi drawing down to the size of a postage stamp and people will still be able to understand what they're looking at.

Next time you create a chibi drawing you're pleased with, why not give it a life outside of your sketchbook? In the pages ahead, you'll learn how to draw a variety of chibis in interesting poses. But you'll also get tips on adapting them for use on everyday items. Sometimes it's as simple

as printing your drawing on a piece of paper and grabbing a pair of scissors. Other projects—like putting a chibi on a black T-shirt—require adapting the art to fit a format you may not be familiar with.

I really hope you'll consider taking on some of these projects. A good chibi drawing deserves a wide audience, and it'll never get that if it's trapped in a sketchbook at the bottom of a drawer. If you love chibi artwork as much as I do, you'll want to make it a part of daily life. These lessons will show you how to do just that.

Chibi Flower Card

People love to receive flowers, and it's all the more special when the flowers are accompanied by a handwritten card. But, let's face it, the cards at the florist are pretty generic.

Chibis to the rescue! Here is a chibi flower card you can make that requires nothing more than a thick piece of paper, your favorite art supplies and a pair of scissors.

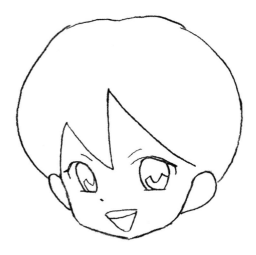

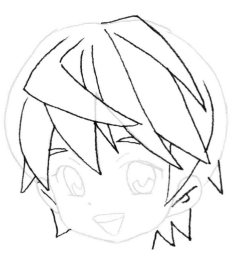

1 Draw the Head and Facial Features

To start, you'll need a piece of thick paper or poster-board (your local craft shop should have plenty of varieties to choose from). Then draw a chibi head, round on the top and very slightly pointed at the chin. As always, the eyes are quite low, with all the facial features occupying little more than the bottom third of the head.

2 Add the Hair, Eyebrows and Ear Details

Consider the hair you see here as a mere suggestion. Bear in mind, though, that a complex, irregular contour may be tricky later on when it's time to cut around the shape with scissors. A pair of eyebrows and one or two lines in the ears is all that remains to complete the head.

3 Draw the Body

Draw the basic guidelines of the body, leaving space for the small sign where you'll write your message. I chose to have one of the legs bent sharply at the knee, adding energy to the pose. Having the upper body tilt in the opposite direction of the lower body is another method of livening things up.

4. Add the Shoulders, Hands and Lower Leg

Now that the sign is in place, draw his upper arms and shoulders behind it. As is always the case with chibi hands, the fingers are short and super cartoony. Add in the other foot, with just a bit of the lower leg visible to make it look like it's kicking back, away from the viewer.

5. Draw the Clothing Details

I chose to give my chibi a checkered shirt, but of course feel free to choose any pattern you like. A few clothing folds at the knees and ankles, and all the important lines are in place.

6. Ink the Drawing and Cut out the Shape

Now it's time to ink over all those lines with your favorite pen. Allow plenty of time for the ink to dry, then carefully erase away the pencil lines. Using a good pair of scissors, cut along the entire edge of the shape, and you're done. Well, almost—you've still got to write your special message and go out and get the flowers!

DESIGN YOUR OWN CHIBI CARDS

Of course, flower cards are just one of the many types of cards out there. Cards for lots of occasions can be made distinctive by the addition of chibis. Remember, they don't have to be perfect. Little imperfections are part of what makes a handmade card charming and worth keeping, long after the store-bought ones have been thrown away. Here are a few examples of chibi cards you could make using the lessons in this book.

WEDDING CARDS AND THANK YOU CARDS...
Our kissing chibi couple from Part 2 is easily transformed into a wedding card and would be equally at home on a wedding announcement. The Joyful Chibi from Part 1 works nicely as a thank you card.

PARTY INVITATIONS.......................
If you want your upcoming bash to be something really special, start things off right with a chibi-style party invitation. Office supply stores often sell kits that allow you to print cards at home using premade templates. We'll learn how to draw this particular chibi later in the chapter.

Do Not Disturb Sign

Parents and siblings have a bad habit of barging into your room whenever they feel like it. You can get them to finally take a hint by way of this little chibi sign, which combines "super cute" with "seriously, please stop bothering me."

This project requires nothing more than a thick piece of paper, your favorite art supplies and a pair of scissors. You won't even need the scissors if you decide not to make a door hanger. Instead, you can leave it as a simple sign taped to your door.

1 Draw the Head, Ears and Eyes

By now you've had a lot of practice drawing chibi heads. This is a fairly standard one: circular on the top, slightly pointed at the chin. The hairstyle I've chosen features bangs and tightly bound pigtails. In preparation for her stern facial expression, I've made her eyes partially squinted shut.

2 Add the Facial Details

And what a stern facial expression it is! Note the zigzag at the end of one eyebrow, indicating a furrowing of the brow. The folds of the eyelids add to the sense that she's squinting her eyes half shut. The mouth is a little asymmetrical, suggesting a snarl to the lip.

3 Draw the Hair and Ear Details

The hairstyle I've chosen is fairly elaborate, but you may opt for something simpler. Consider, though, how the spikiness of the hair adds to her thorny personality. Gently flowing hair would give us a very different feeling about her. As usual, adding a couple of lines to the ears helps convey the structure.

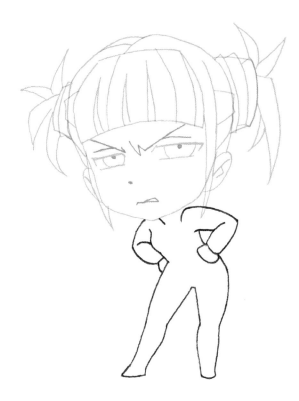

 Draw the Body

For this chibi, I've made the body extra tiny, adding to the cartooniness of the image. When drawing the legs, pay close attention to the angle and curve of each line as well as the blank spaces in between.

5 Add the Clothing Details

Since the body is so small, I've tried to stay away from too many folds and wrinkles. The goal is to convey all the various pieces of clothing—shoes, pants and hoodie—with the absolute minimum number of lines.

6 Ink the Drawing

Grab your pen and ink all the lines. After the ink has dried, you can erase all the pencil lines away. You can write your "DO NOT DISTURB" message by hand, or print it out using a computer font. If you do choose to turn this chibi into a door hanger, it's best to mount the drawing on a thick piece of posterboard, so it'll hold up to wear and tear.

CHIBIS ON SIGNS

Chibis are a great way of taking average, everyday signs and turning them into something really special. Here are a couple of ideas for chibi-style signs you can make at home with a minimum of fuss.

GARAGE SALE....................................
Signs are all about getting information to people. In the case of garage sale signs, they play a crucial role in drawing people to your home on the big day. By adding a chibi (like this one, adapted from the Running Chibi lesson in Part 2), you make your garage sale signs really stand out.

I created this one using the computer, but you could do the whole thing by hand. Simply create one good master version, then take it to a print shop and have them make a set of copies for you.

PLEASE REMOVE YOUR SHOES...............
In Japan, no one would dream of entering a home with their shoes on, and the practice has become common in many other countries. If you need to remind visitors of this custom in your home, a chibi sign near your front door is a cute and gentle way of getting the message across.

T-Shirt Designs

These days pretty much anything can be put on a T-shirt, but that doesn't mean everything *looks good* on a T-shirt. Artists assigned with creating a T-shirt design know it should be able to be easily seen and understood, even from a distance.

Happily, that's pretty much a defining characteristic of chibis. In this lesson, you'll learn how to draw a chibi rocking out with an electric guitar, an image that's—you guessed it—able to be seen and easily understood, even from a distance. In doing so, you will learn some of the basic principles of T-shirt design.

1 Draw the Head and Facial Features

No need to re-create each and every spike of hair you see here. Indeed, you should feel free to give your chibi any hairstyle you like. Drawing the eyes squinted shut adds to the feeling of joy we see on his face. Since his head is turned away from us, the eye on the right—being a little farther away—is drawn a little smaller than the other.

2 Add the Hair and Facial Details

Now that the contour of the hair is in place, add the details, including strands of hair across the forehead. I added a little fang to his upper teeth, a common feature for chibis, as it is considered cute in Japan.

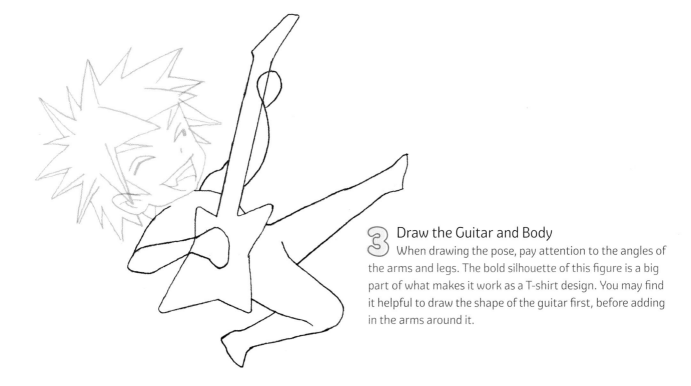

3 Draw the Guitar and Body

When drawing the pose, pay attention to the angles of the arms and legs. The bold silhouette of this figure is a big part of what makes it work as a T-shirt design. You may find it helpful to draw the shape of the guitar first, before adding in the arms around it.

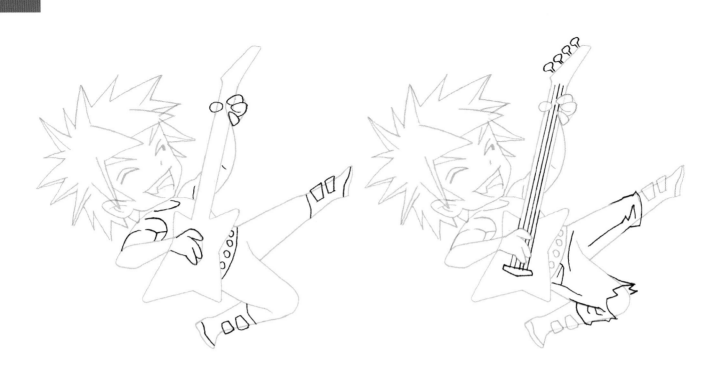

4. Add the Clothing Details and Hands

Chibi hands are usually super simple, but a guitar pose requires slightly more detail. Note the angles of each finger before adding them to the drawing. As for the boots and belt, feel free to come up with your own ideas for these.

5. Draw the Guitar Details and Jeans

A chibi guitar drawing is always going to be a simplified version of a real guitar, but in the case of a T-shirt design it needs to be simple indeed. I've reduced it to little more than strings and tuning keys. Don't hesitate to use a ruler for the strings if you want them to be as straight as possible.

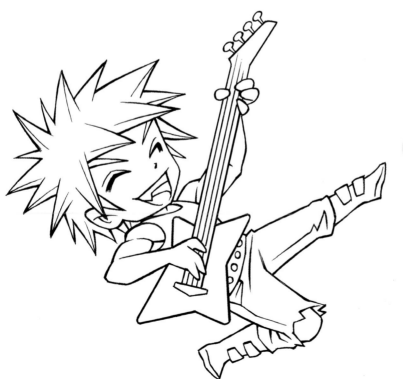

6. Ink the Drawing

When inking a T-shirt illustration, make sure the lines are bold and clear. This will make them reproduce well on cloth. Once the ink is dry, carefully erase all the pencil lines. For advice on adding color, check out the tips at the end of this chapter. There are advantages to using digital coloring for a project like this, since most T-shirt printing services will want your design as a digital file rather than as original art on paper.

BLACK T-SHIRTS

Putting your chibi illustration on a T-shirt can be as simple as uploading a file to a website and clicking "order." But some T-shirt projects present unique challenges. Black T-shirts, for example, often feature images that have been reversed, so that all the black lines print as white. Here are some tips to help you out if you'd like to take on such a project.

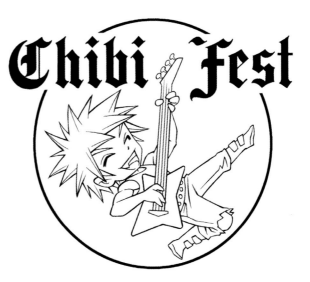

SIMPLIFY YOUR DESIGN...
Start with a simple black-and-white design. You may find that you need to strengthen the linework to make the image extra clear. Here you see how thin lines look on a white background: acceptable, perhaps, but this image won't be bold enough to print on a black T-shirt.

REVERSE THE IMAGE..............................
Don't leave anything to chance. Scan your improved image and change all the black lines to white using photo editing software. Then view them against a black background. In the case of my Chibi Fest illustration, I found that the hair and the face had to be two different colors to make the new design work. Necessary changes like this won't become clear to you unless you give yourself an accurate preview.

Printed Stickers

If you have access to a decent home printer, then you are just a few steps away from printing your chibi drawings onto a sheet of custom stickers. Office supply stores sell a wide array of blank sticker sheets that can be fed into the paper supply of any home printer. Given a little practice, you can become a wiz at printing chibi stickers that are both useful and pleasing to the eye.

In this lesson, I'll show you how to create a chibi drawing that can be turned into a bookplate so that friends who borrow your books don't get them mixed up with their own.

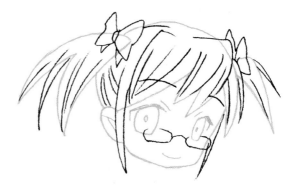

1 Draw the Head, Hair and Facial Features

This drawing has quite a few details, so we need to fit a number of things into this first step. If you choose to give your character pigtails, as I did, note that the one on the right is drawn smaller since it is farther away. When drawing the eyes, pay attention to the big gap of blank space between them.

2 Add the Hair Details, Ribbons and Glasses

No need to add as many lines to the hair as I've done here. Add as few as you like, but remember to make them curve, following the direction that the hair flows. Note that there are little gaps in the frame of the glasses. This is to make sure the glasses don't obscure the eyes.

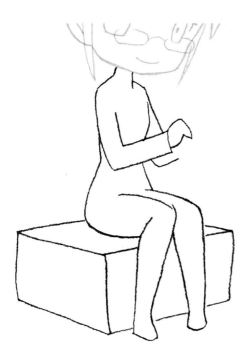

3 Draw the Body and Books

When drawing the torso, pay attention to the point at which the neck joins the head: just to the left of the chin. Also focus on the width of the shoulders compared to the hips. In chibi proportions, it's common for the hips to be much wider than the shoulders. The angle of the lower legs—leaning in so that the knees touch—adds cuteness to the pose.

4 Add the Clothing Details

I've chosen a somewhat fancy uniform for her, but you may prefer something simpler or more casual. If you choose to include the pleated skirt, pay attention to the way the pleats fan out as they drape across her leg.

5 Add the Book Details, Socks and Shoes

Using the guidelines from Step 3, divide the seat structure into three separate horizontal blocks. Note that the spines of the books curve outward just a bit. I chose to have the top book facing in a different direction from the two books beneath it. This adds visual interest and helps us view them as three separate objects.

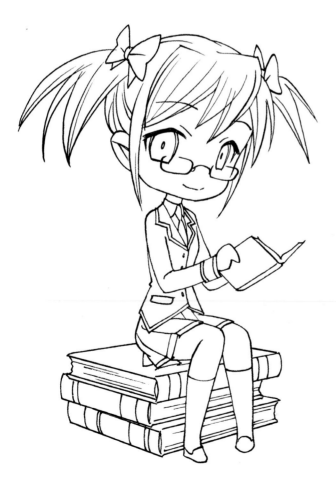

6 Ink the Drawing

There's something rather delicate about this drawing, so I advise inking it with light, clean lines. In my version every line is done with a single stroke of the pen with the exception of the upper eyelashes, where the lines are built up just a bit. Once the ink has dried, erase all the pencil work, and you're done.

MAKING STICKERS AT HOME

In addition to a home printer, you'll need a scanner and some form of basic layout software. Usually, the companies that make the sticker sheets sold in office supply stores provide access to templates on their websites. These templates will allow you to make your chibi pictures line up perfectly with whatever printable sticker sheets you have.

If you don't have a scanner, you may be able to make do with a digital camera or a camera phone. Simply take a photo of the chibi you've drawn, then transfer the photo to your computer or whichever device you're using to prepare your stickers for printing.

STICKER SHEET VARIETIES...............
When shopping for sticker sheets, keep an eye out for the many unique types being produced today. They are sold in a variety of shapes and sizes, including circular and oval-shaped stickers.

Here, the sticker sheets have a base color of brown rather than white. This simple change makes a big difference in the look of the address labels for Panda Girl Productions.

Customized Buttons

As an artist you may someday need to design a custom button, either for an event or just to express your support for a specific cause. Chibis are among the few types of art that work really well on buttons. If the linework is bold and simple, a chibi will look great even when it's shrunk down to such a tiny size.

In this lesson, we'll imagine we need to create a button for a "fun run" event. A chibi jogger makes the perfect focal point for the design, conveying both the "run" and the "fun" in a single image. This type of running pose is well worth learning. It's a tricky thing to draw from memory!

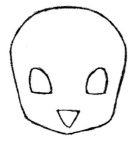

1 Draw the Head, Eyes and Mouth

This chibi lesson features a head that's facing straight toward the viewer. This style calls for eyes of similar size, placed symmetrically upon the face. As is so often the case with chibis, the facial features are quite low on the head, accentuating the youthfulness of the character.

2 Add the Hair and Facial Details

A ponytail hairstyle is great for running poses, since it can be shown bouncing around in the air, adding to the sense of motion in the drawing. Note that the eyelash lines are shifted a bit to the left and the right. This adds focus to the eyes, as if she is staring straight at us.

3 Draw the Hair Details

When designing a button, it's important to keep the details to a minimum, so I've held back from adding loads of lines. Still, I added two stray strands of hair that curve away from the rest of the hair. This furthers the sense of momentum in the pose.

4. Draw the Body

Take your time with this step; it's by far the most challenging. The difference between the width of the shoulders and that of the hips is more subtle. Note the angle of the extended leg—it tilts enough for the foot to be in line with the center of the body. Leave the hand details until the next step. For now, it's enough to draw them as simple boxlike shapes.

5. Draw the Clothing and Leg Details and Hands

When drawing her shorts, pay attention to the lines defining the edges. They curve to reveal the surface of the body beneath. Add her rear foot behind her knee with just a bit of the foreshortened calf visible on the far left side.

6. Ink the Drawing

Grab your pen and ink all the lines. As with the T-shirt design, bold linework is important. The whole image could end up little more than 1 inch (25mm) high, and you want those lines to still be printable. For tips on adding color, turn to the end of this chapter.

USING CHIBIS TO PROMOTE AN EVENT

Buttons aren't the only things an artist might be called upon to design. Many events require posters, tickets, flyers and all manner of other items to help spread the word around town.

Chibis can take pretty much any gathering and bring a whole new level of fun to it. Here is some advice for using your chibi skills to promote any special occasion.

TICKETS..

Just as with our button design, a ticket forces you to work within a very constrained space. In the example here, I used the black T-shirt version of the little chibi guitarist. For something that's going to be shrunk down to the size of a square inch (25mm), a simple design is much easier to interpret than something crawling with details.

POSTERS..

Adding a chibi to a poster design instantly makes it more eye-catching. Though you may be tempted to fill the entire poster with your drawings, don't forget the poster's primary job is to spread information about the time, cost and location of the event. If you've got access to a computer, using a font for all the lettering is a huge time-saver.

Rubber Stamps

Most craft stores have a section devoted to rubber stamps with a wide variety of images to choose from and ink pads in all the colors of the rainbow. Sadly, you're not likely to find any chibi characters among the rubber stamps in the store. But don't let that stop you!

In this lesson, I'll teach you how to draw a picture of a chibi graduate, then turn it into a custom rubber stamp like the one you see below.

1 Draw the Head Shape and Facial Features

Start with the usual chibi head shape. Note that the iris shapes are flattened on the bottom. This helps convey a cheerful facial expression because the eyes squint when someone smiles. As always, pay attention to the blank spaces between the eyes and to their location relative to the top and bottom of the head.

2 Add the Graduation Cap and Facial Details

Now that the guidelines of the head are in place, draw the graduation cap. It's different from most hats, of course, not only in terms of its shape, but also in how little of the head it covers. I added a seam to the base of the cap to help convey its structure.

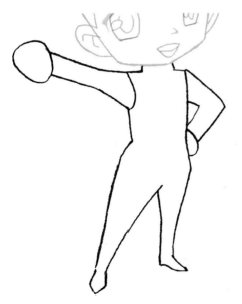

3 Draw the Body

When drawing the pose, pay attention to the angles of the legs. One of them is stepping out diagonally, while the other is much more vertical, carrying the full weight of the body. We'll get to the details of the hands in the next step. For now, it's enough to draw them as simple circles.

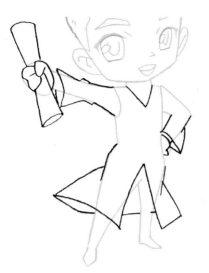

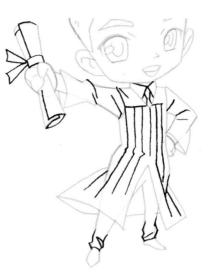

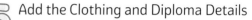

4 Add the Gown and Diploma
I've chosen to billow out his gown in a capelike way to add a sense of motion to the pose. By showing both the exterior and a bit of the interior of the gown in this area, you can make its structure easily understood. When drawing the hand, make the thumb overlap the fingers to convey the appearance of a firm grip.

5 Add the Clothing and Diploma Details
A graduation gown is an unusual piece of clothing. This one features long vertical pleats in the front. Take care to make them fan out at the bottom, following the billowing structure established in Step 4. A small curlicue line at the bottom of the diploma can convey the idea of a rolled-up piece of paper.

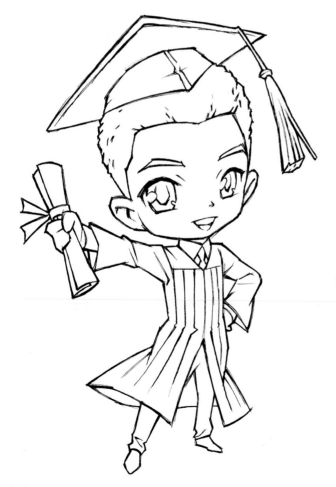

6 Ink the Drawing
Grab your pen and ink all the lines, ideally with bold, clean strokes. Once the ink has dried, you can erase all the initial pencil work. There you have it: a jubilant chibi graduate, ready to go out and make his mark on the world!

DESIGNING A RUBBER STAMP

Seeing one of your chibi illustrations printed by way of a rubber stamp is a uniquely fun experience for an artist. If you've never ordered a custom rubber stamp before, I'd encourage you to give it a try at least once. Here are some tips to guide you through the process.

SIMPLIFY YOUR DESIGN...........................

The requirements of rubber stamp design are similar to those for black T-shirts. If you've got a full-color design, you need to simplify your design into a black-and-white image.

In the case of my chibi graduate, I found that the basic linework robbed of color looked a little unfinished, like a page from a coloring book. So I chose certain parts of the illustration to fill with solid black. This meant taking certain lines (like the details of his gown) and reversing them from black lines to white lines. Take your time and make sure you're 100-percent satisfied with your design before declaring it finished. It's going to be chiseled in rubber, so to speak, and you don't want to notice mistakes after it's too late.

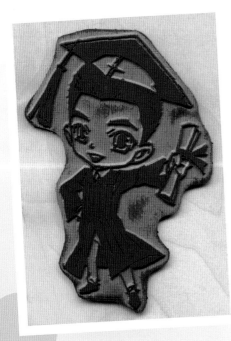

SEND THE IMAGE TO A RUBBER STAMP MANUFACTURER............

Many rubber stamp stores can help you with this part of the process. Alternatively, you can find services online and take care of the order on your own. The main choice that remains is the size of the final stamp. Printing various sizes of your design on a home printer can help you decide how large or small you want the final design to be.

In my experience, there is no need to flip the design before sending it to the rubber stamp maker. They will assume it needs to be flipped and do that part for you.

Turning a Real Person Into a Chibi

Inventing your own fictional chibi characters is great, but there's nothing quite like drawing a chibi version of someone you know. Not only will you have fun doing it, but just wait until you see how delighted your friend is to receive this one-of-a-kind personalized portrait.

For help in showing how it's done, I turned to Chloe Noelle, a super-talented actor who has been in the cast of TV shows like *True Blood* and *New Girl*. Chloe kindly sent me a photo of herself that I could use as an example in this lesson, allowing me to show which features change and which stay the same when an artist takes a real-life person and transforms her into a chibi.

While you don't necessarily need to base your chibi portrait on one particular photo, it can be a helpful way to practice. The pose is already worked out in advance, so you can focus all your attention on the "chibi-fying" process.

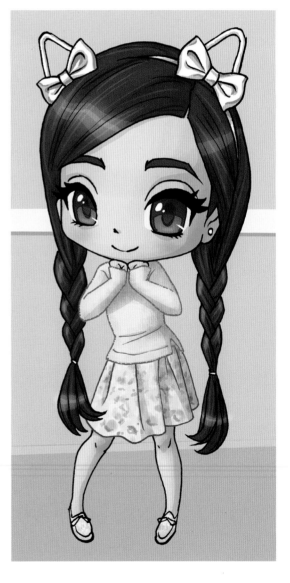

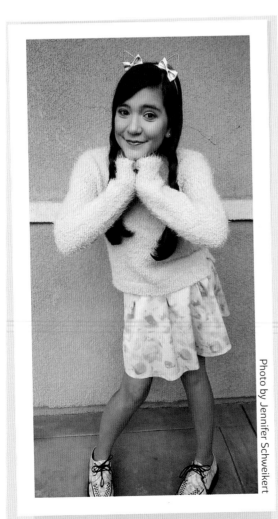

Photo by Jennifer Schweikert

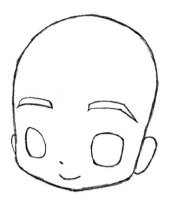

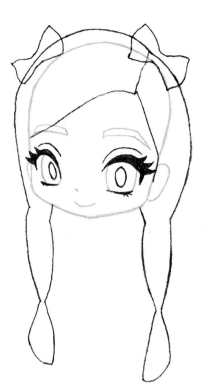

1 Draw the Head Shape and Facial Features

Since Chloe's head is tilted a bit to the right in the photo, I've done the same with my drawing. It's not necessary to make the facial features look like Chloe's at the outset. Indeed, you need the basic structure to have standard chibi-style proportions at this stage. The personalization comes in the details.

2 Add the Hair and Facial Details

I decided to draw the braids in proportion to the head, making the length of each braid equal to the height of the head, top to bottom. Though the eyes themselves might be regarded as typical chibi, note how the folds of the upper eyelids are more prominent than elsewhere in this book. This is a feature taken from the photo, a distinctive aspect of Chloe's eyes.

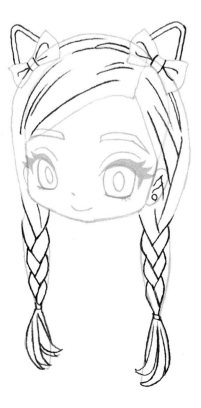

3 Draw the Hair Details, Bows and Earrings

When adding details to the hair, I carefully observed Chloe's photo, making sure the part was in the same place and that the tips of the braids curled in the same direction. You should do the same when trying to draw chibi versions of your friends. The facial features are always a compromise between a more generic chibi and the specifics of your friend's face looks like. The hair can be more of a perfect match.

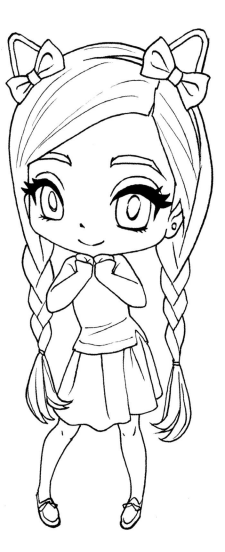

4 Draw the Body

I've made an effort to re-create Chloe's pose while maintaining traditional chibi proportions. The angles of the forearms and legs are more or less an exact match. But for the silhouette of the body itself I've mostly ignored the photo and instead drawn a typical chibi body: wide at the hips, narrow at the shoulders.

5 Add the Clothing Details, Knees, Shoes and Hands

When drawing a chibi version of your friend, it may be tempting to focus exclusively on the face and hair. But you should pay close attention to the clothing—it can make a huge difference. If people viewing the image can say, "Oh yeah, I've seen her wearing those clothes before," then you've helped them understand that your picture isn't just a random cartoon, but a specific chibi portrait.

6 Ink the Drawing

Time to grab your pen and ink over all the lines. After the ink has dried, carefully erase away the pencil lines. Coloring is an important final touch, especially when it comes to matching your friend's eye and hair color. For tips on adding color, check out the section at the end of this chapter.

CHIBI VERSIONS OF FAMOUS CHARACTERS

Equal to the fun of drawing your friends as chibis is drawing famous characters as chibis. Pretty much any character you're a fan of—whether they're from a brand new anime or a Shakespeare play—can be given the chibi treatment. Here I've tried my hand at three famous characters from the world of children's books.

LITTLE RED RIDING HOOD..
When doing a chibi version of a well-known character, you've got to get the key elements into the drawing, in this case the hood and the basket. When you draw a chibi version of, say, Naruto, I'd advise you to base your details on real Naruto illustrations, rather than draw them from memory.

ALICE IN WONDERLAND..
Does the pose look familiar? That's right, it's the same pose that Chloe did for her photo! Note that I opted for moderate hair length here. I could have had her hair reach nearly to the ground, making it proportional to her head rather than to her body.

SNOW WHITE..
Certainly the most famous version of Snow White is the Disney version. But the character dates back to the Brothers Grimm, so artists should feel free to draw her any way they like.

Personalizing a Phone Case

There is an incredible variety of phone cases on the market these days. However, if you're looking for one with a chibi character on it, your options are sadly limited. But, hey, who needs a factory-printed chibi anyway? You're more than skilled enough to draw a chibi on the phone case yourself!

This lesson will show you how to draw a cell phone chibi, perfect for adding to the phone case of your choice. I've made the design super simple so that it can be reproduced with permanent markers or craft paints. Make sure to test your art supplies on the inside of your phone case before using them for the final artwork.

The hiragana lettering you see here is the Japanese phrase used when answering the phone: "Moshi moshi!"

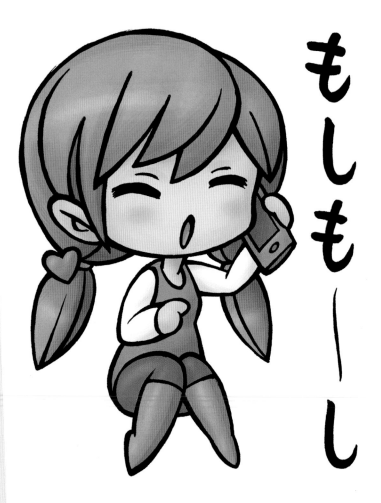

もしもーし

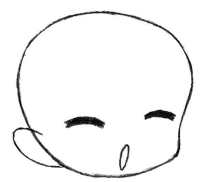

1 Draw the Head Shape and Facial Features

This one's all about simplicity. Still, you should practice drawing this character at least once with pencil on paper before moving on to your phone case for the final. As always, pay attention to the shape of the head—especially to the subtle curve of the cheek on the right side—and to the location of the eyes.

2 Draw the Hair and Facial Details

This hairstyle is all about curving lines. I've chosen to have the pigtails pointing slightly outward to the left and right. This will leave extra space for drawing the body later on. Details such as the folds of the eyelids and the structure of the ear are optional, especially if you're having to draw this character at a reduced size.

3 Add the Hair Details

As is so often the case, the various strands of hair curve to follow the surface of the scalp. I decided to put a little heart-shaped fastener on one of the pigtails to add visual interest.

4 Draw the Body

For a minimalistic chibi like this one, the realities of human anatomy can be cast aside and replaced with a series of simple shapes. The proportions of the head to the body are greatly exaggerated, even by chibi standards. Note the angles of the lower legs, tilting inward so that the knees touch.

5 Add the Final Details

With the basics of the body in place, you can now draw the neck, the hands, the legs and—at last!—the phone. Note how the tops of the boots curve across the calves. Even in this super cartoony style, it's helpful to have lines bend to convey the form of the body.

6 Ink the Drawing

Grab your pen and ink over all the pencil lines. The linework here is super thick and bold. Practicing your inking method at least once on paper will guarantee good results when you move to re-creating the final art on your phone case.

PERSONALIZED LUGGAGE TAG

Almost any item you own can be personalized with a chibi drawing of some kind. Here I took an ordinary luggage tag and made it more distinctive by adding a globetrotting chibi.

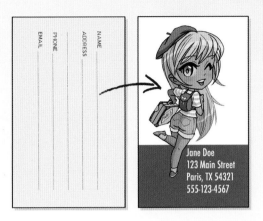

STORE-BOUGHT TAG...

Most luggage tags will come with a simple cardboard insert, usually with nothing more than a few lines for your address or phone number. I removed it and set about designing a replacement.

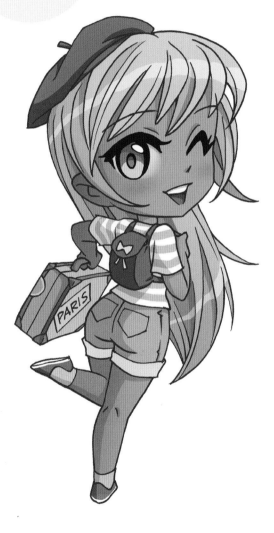

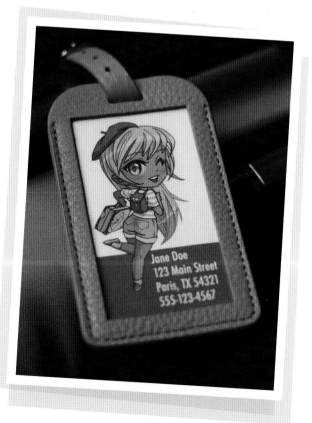

CUSTOM FITTING YOUR ART...

By measuring the window of the luggage tag, I was able to figure out the available size for the illustration and text. I scanned my art into the computer and printed it out at the size I needed, but you could do the whole thing by hand for a more crafted look.

Pop-Up Chibi

A few years ago I was trying to think of a new type of video I could do for my YouTube channel when I hit upon the idea of a pop-up chibi. By drawing a chibi on thick paper like bristol board, then cutting around the figure's contour with a craft knife, I was able to fold it up and away from the paper at a 90-degree angle. The final effect was the chibi standing up on its own, escaping its 2-D confines to become more three-dimensional.

In this lesson I'll show you how to do a pop-up chibi that appears to be lying on the floor making drawings. Drawings of—what else?—more chibis!

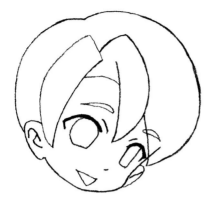

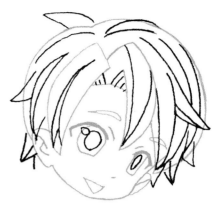

1 Draw the Head Shape and Facial Features

Remember to begin with thick paper such as bristol board. The pose requires his head to be tilted at an angle so that he'll appear to be looking at his drawing. It also needs to be shown in a three-quarter point of view, which means the eye on the right is compressed a bit to make it look farther away.

2 Add the Hair and Eye Details

Whatever hairstyle you settle on, now's the time to add details. I chose to put in a few stray strands of hair, curving away from the head. Note the large size of his pupils. I find that this can make a character look more innocent and purehearted.

3 Draw the Body

This is that rare pose that requires a ruler (or an incredibly steady hand). The underside of his body needs to be a perfectly straight line so that you can fold along it when completing the project. When drawing the contour of the body, note the angles of the upper arms as well as the width of the entire image. From one side to the other, it's a little less than three heads wide.

4 Add the Clothing, Hands and Pencil

With the body contour now in place, add lines for the edges of his shirt and pants. I've made the fingers more defined than chibi fingers usually are, mainly so that we can see his grip on the pencil. Note that the tip of the pencil needs to rest exactly on the lower line of the image, a crucial part of completing the 3-D illusion of a pop-up chibi.

5 Draw the Clothing Details

You can add more or fewer folds and wrinkles, depending on the level of realism you want to achieve. As usual, the locations for clothing wrinkles tend to be at the ankles, knees, waist and elbows.

6 Ink the Drawing

Ink the lines, wait for the ink to dry, then erase the pencil guidelines. When I ink a pop-up chibi project, I like to make the contour line extra thick. This allows a bit more wiggle room when I cut along that line with a craft knife in the final step. Advice for completing the project is on the very next page.

Completing Your Pop-Up Chibi

Once you've finished inking and coloring the chibi character from this lesson, you're only a few steps away from completion. Read on!

1 Cut out the Body

While you may be able to get through this step with a pair of scissors, a craft knife is the ideal tool for the job. Take your time and carefully cut along most of the chibi character's contour, as shown by the red line in this illustration. Caution: Don't cut the flat area between the tip of the toe and the elbow.

2 Create the Tiny Drawings

Using ordinary paper (no need for bristol board here), cut out three or four small rectangles of paper, small enough to be proportional to your chibi. They should be no more than an inch or two (25 to 51mm) high. Next make tiny drawings on them, whatever images you feel like. I chose to do drawings from three of the lessons in this book.

3 Slide the Drawings Into Place

Fold the chibi from Step 1 into an upright position. Then you can slide one of the drawings from Step 2 under his hand, creating the illusion that our little chibi artist is putting pencil to paper.

Chibi Calendar

For the final lesson of the book I thought I'd propose something more ambitious: a homemade chibi calendar. That's right, you'll need to do at least twelve different chibi drawings to complete this project, one for each month of the year. Will it take you more than a day to complete it? Definitely. But when you're done, you'll have something you can really take pride in.

I'll get you started with an autumn chibi, perfect for the month of September or October. As for the other months, well, you're going to have to get creative. But, hey, you've drawn an awful lot of chibis by now. You're ready!

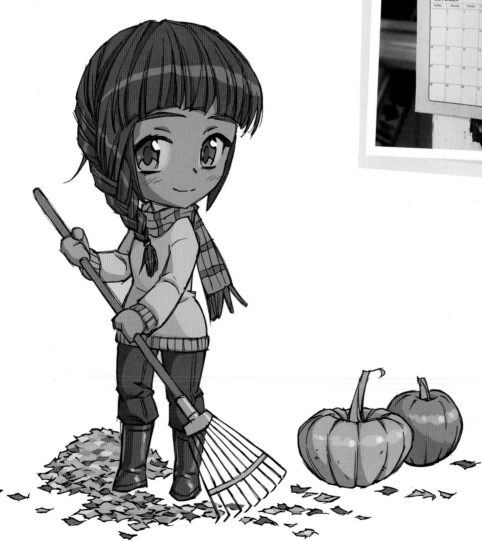

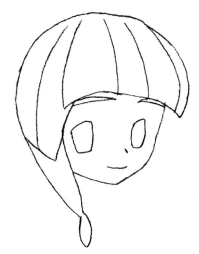

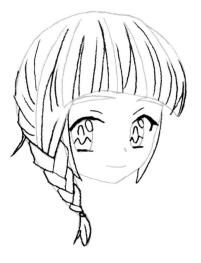

1 Draw the Head, Facial Features and Hair

We're at the graduate level now: Draw the basic guidelines of the head, hair and facial features in a single step. I decided to give our character a distinctive braid, but you may prefer a different hairstyle. As always, note the spacial relationships between the eyes, nose, mouth and jawline.

2 Add the Hair and Facial Details

Drawing the bangs should be a breeze, but the braid is going to take a little more time. Go back to the braid lesson in Part 2 if you need a little help. These eye shapes are big enough to contain a lot of detail. Why not challenge yourself to add some extra details?

3 Draw the Body and Rake Handle

There's a lot to cover in this step, so take your time and study the angle and length of each line before you draw. Note the width of her shoulders relative to her hips. It's helpful to draw the rake handle before the hands and arms. Going at them the other way around would make it tricky to line up the hands.

4 Add the Hands, Clothing Details and Rake

With the basic pose in place, move on to the details of the hands. Take care to draw the fingers curving around the rake handle rather than going straight across. I chose to draw a scarf to add to the cool weather look. Note that the bottom edge of her sweater must be parallel to the tips of her toes.

5 Draw the Clothing Details and Rake

I've really pulled out all the stops with the details here, but keep things simple if you prefer. Drawing a vertical seam along the sides of both legs is a good way to create a denim effect. When drawing the spokes of the rake, do your best to make them evenly spaced.

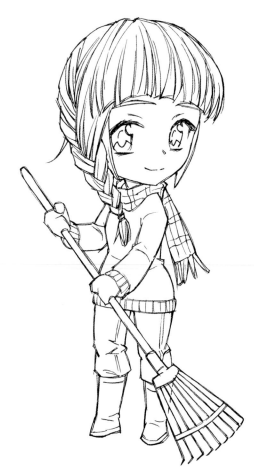

6 Ink the Drawing

This is certainly among the most detailed images in the book, so the inking could—and probably should—take you longer than the other lessons. Once the ink has dried, erase away all the pencil lines. For tips on adding color, check out the color section at the end of this chapter. Advice for completing your chibi calendar is coming up next.

MAKING YOUR OWN CALENDAR

Most factory-made calendars are folded in half and stapled by machine along the fold. While you may enjoy the challenge of replicating this technique at home, I'm partial to the idea of getting both the artwork and the calendar month together onto a single sheet of paper. Not only do you avoid the challenge of getting staples into a hard-to-reach location, but you end up with a calendar that is unique and artistic in its approach.

DOWNLOAD READY-MADE CALENDAR GRAPHICS..............
Trying to create all those little numbered squares by hand (or even on a computer) would be a painstaking task. A quick Internet search yields plenty of high-resolution graphics for each month of the year. Once you've downloaded all the months for the current year, you can get to work integrating them into your chibi calendar.

EXPERIMENT WITH DIFFERENT CALENDAR FORMATS.....................
The classic calendar arrangement is to have the art up top and the days of the month dropped down to the lower half. But no one says you have to do it that way. Here you can see two approaches that move the calendar squares to a different location, while still leaving space for the artwork. Why not experiment and find a look that's all your own?

ADDING COLOR TO YOUR CHIBIS

The real focus of this book is teaching people how to draw chibi characters, but many of you will want to add color to your drawings, no doubt. So here are tips for three different coloring methods: colored pencils, markers and digital coloring.

COLORED PENCILS...

Colored pencils are a great way to get into coloring if you're just starting out. They allow you to add color gradually and may even be partially erasable if you make a mistake. Start with a base of flat, pale colors, as you see in the first picture. Build on top of that layer with darker versions of the same colors. If you're patient and build the colors up gradually, you can achieve results like you see on the left.

MARKERS...

Using high-quality art markers is among the most popular methods for coloring chibi illustrations. They're not cheap, but they yield great results. As with colored pencils, the two-layer approach is a fine way to start. Take care to use only pale colors for your base layer as shown on the left. Markers often come in super dark shades, and you can't really layer anything on top of them. It can be helpful to test every marker on a sheet of scrap paper before using it to make sure you know exactly what the real color will be.

Digital Coloring

All the illustrations you see in this book were colored digitally. Every artist finds his own preferred way of coloring—there is no single right way. Here's a four-step method that has worked well for me. Everything you see here can be done with a stylus on a tablet, or by pointing and clicking with a mouse.

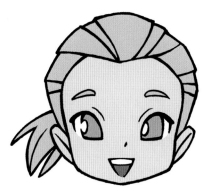

1 Complete a Base Layer

Just as with colored pencils and markers, start with a flat, pale base. Most digital editing software allows you to work in true layers, as if you were building up the colors on different sheets of glass, stacked one upon the other. Everything you do on one layer is separated from all the other layers, allowing you to make changes without affecting the other work.

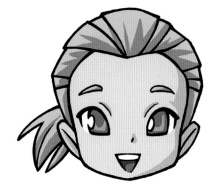

2 Add the Darker Colors

Add darker versions of each color on a separate layer. As you become more experienced with digital coloring, you may begin to work in a more painterly way, with multiple strokes that build up a rich spectrum of hues.

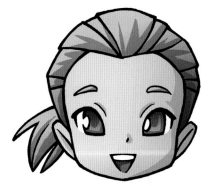

3 Add Gradients

Introduce a subtle light-to-dark shift within three key areas. This creates a gradual change of color in the hair, the skin and within each iris. This small shift makes a huge difference in how 3-D the art appears.

4 Add Highlights and Finishing Touches

I added a streak of white to the hair to make it appear shinier. Then I added areas of blush to her cheeks using an airbrush effect.

A digital coloring professional can, of course, take this image to a much higher level. But for an absolute beginner, this four-step method is not a bad way to get started.

INDEX

.: ABOUT THE AUTHOR :.

Mark Crilley was raised in Detroit. After graduating from Kalamazoo College in 1988, he taught English in Taiwan and Japan for nearly five years. He has written and illustrated more than thirty books, including *Mastering Manga*, which has been translated into eight languages. His work has been featured in *USA Today*, *Entertainment Weekly* and on CNN Headline News, and his popular YouTube videos have been viewed 350 million times and counting. He lives in Michigan with his wife, Miki, and children, Matthew and Mio.

DEDICATION

This book is dedicated to my lovely wife, Miki

fw
a content + ecommerce company

Other fine IMPACT Books are available from your favorite bookstore, art supply store or online supplier. Visit our website at fwcommunity.com.

22 21 20 19 18 5 4 3 2 1

DISTRIBUTED IN CANADA BY FRASER DIRECT
100 Armstrong Avenue
Georgetown, ON, Canada L7G 5S4
Tel: (905) 877-4411

DISTRIBUTED IN THE U.K. AND EUROPE
BY F&W MEDIA INTERNATIONAL LTD
Pynes Hill Court, Pynes Hill, Rydon Lane, Exeter, EX2 5AZ United Kingdom
Tel: (+44) 1392 797680
Email: enquiries@fwmedia.com

ISBN 13: 978-1-4403-4094-9

Edited by Mary Burzlaff Bostic
Production Edited by Jennifer Zellner
Cover Designed by Clare Finney
Interior Designed by Brianna Scharstein
Production Coordinated by Jennifer Bass

Metric Conversion Chart

TO CONVERT	TO	MULTIPLY BY
Inches	Centimeters	2.54
Centimeters	Inches	0.4
Feet	Centimeters	30.5
Centimeters	Feet	0.03
Yards	Meters	0.9
Meters	Yards	1.1

Ideas. Instruction. Inspiration.

Check out these IMPACT titles at IMPACTUniverse.com!

These and other fine IMPACT products are available at your local art & craft retailer, bookstore or online supplier. Visit our website at IMPACTUniverse.com.

Follow IMPACT for the latest news, free wallpapers, free demos and chances to win FREE BOOKS!

Follow us!

IMPACTUNIVERSE.COM

· Connect with your favorite artists

· Get the latest in comic, fantasy and sci-fi art instruction, tips and techniques

· Be the first to get special deals on the products you need to improve your art